Edgar Degas

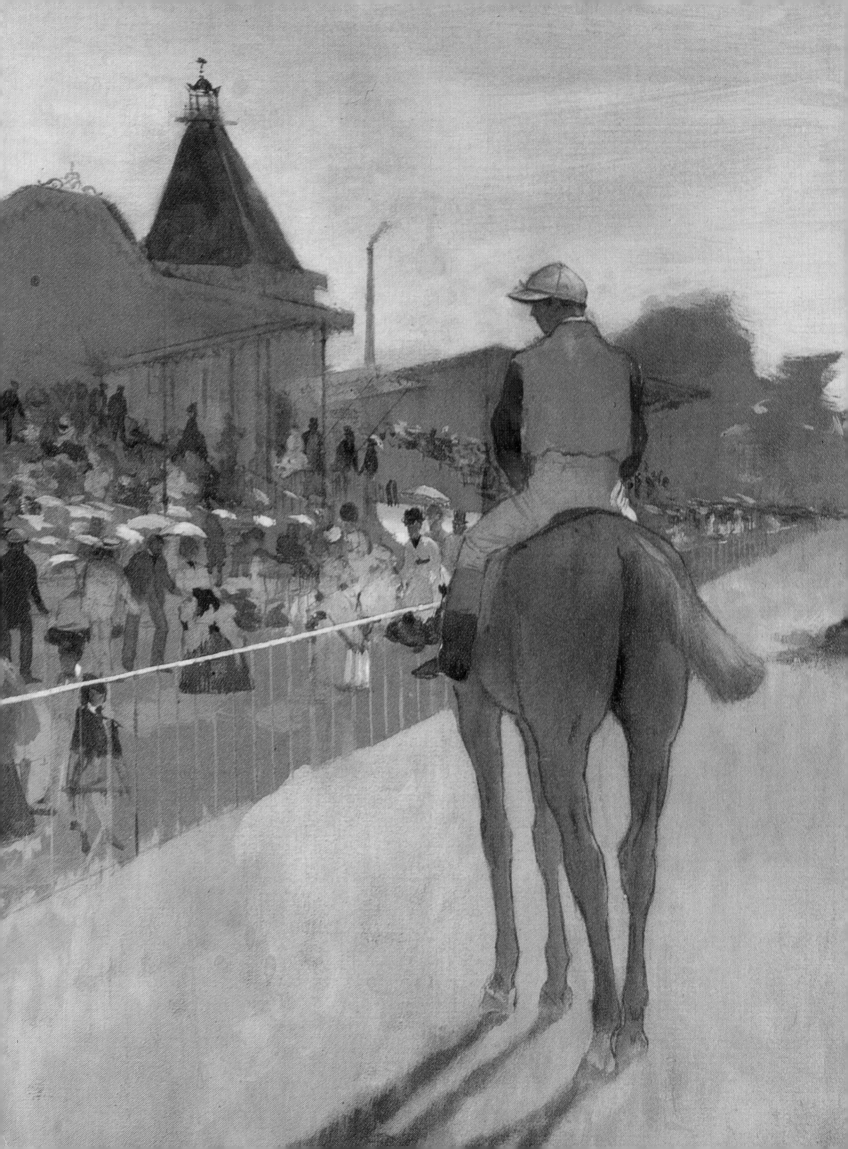

Edgar Degas

Trewin Copplestone

GRAMERCY

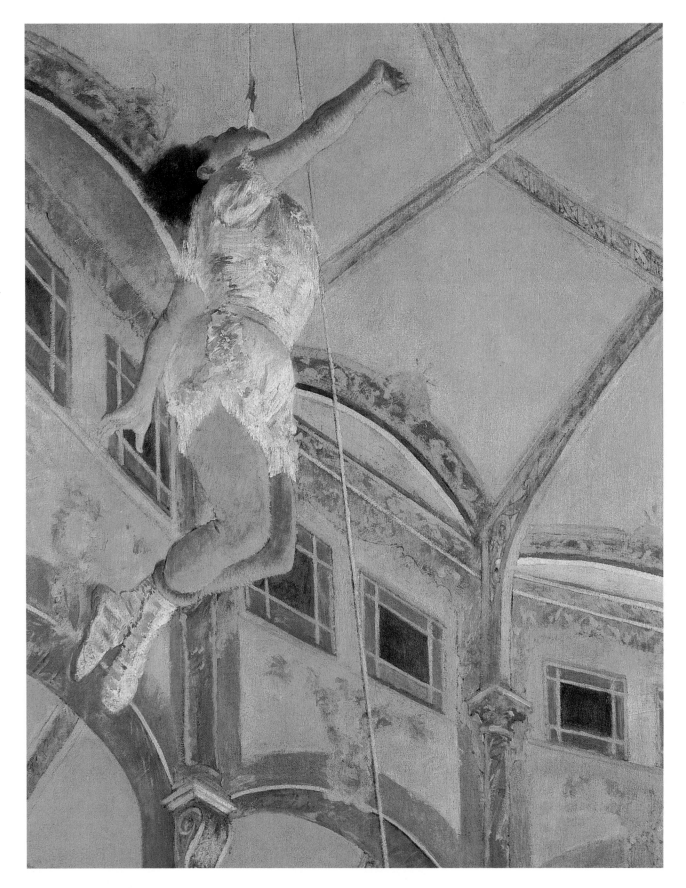

Random House New York • Toronto •London • Sydney • Auckland
http: / / www.randomhouse.com/

Printed in Italy

ISBN 0-517-16066-8

10 987654321

List of Plates

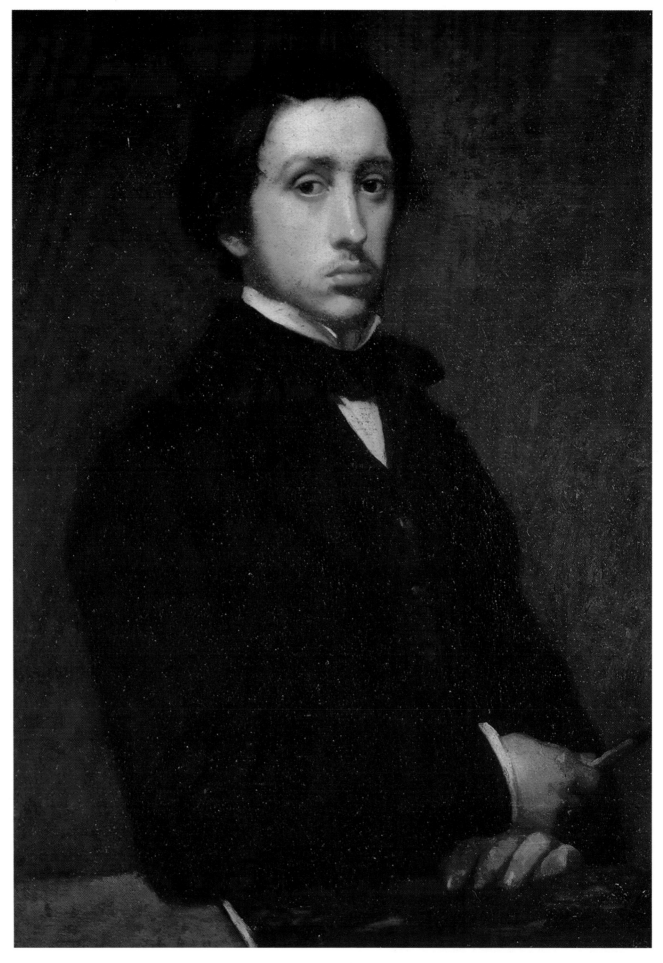

The qualities which distinguish the significant creative artist from the talented amateur are not easy to establish precisely. But distinction is usually immediately recognizable, even when the subject-matter chosen by the artist is not itself especially attractive or appealing in a conventional sense. Such significant qualities are not essentially, or even primarily, technical but lie ultimately in the nature and sensitivity, the innate individuality of the artist and his ability to find an effective form in which to express them. Quality differences are unique to each individual and are part of the human condition.

It is this quality of distinctive originality that is immediately apparent in the work of Edgar Degas. Of course, it is important also to acknowledge and examine his ability to use those of the techniques available to him that effectively express his intentions. This study considers Degas' life, character and artistic achievement. Since no one lives outside his social and cultural context, the background to his life will be considered where appropriate and helpful.

The popular romantic perception of the 19th-century Parisian artist as a bohemian, given to excesses, living and working in a dingy garret in the back streets of Montmartre, was very different from the milieu into which Degas was born and grew up and which conditioned his future attitudes and behaviour. His life, at least in his earlier years, was one of quiet privilege and

PLATE 1
Self-Portrait with Crayon (1855)
Canvas and oil on paper, $31^{7}/_{8}$ x $25^{1}/_{2}$ inches
(81 x 64.5cm)

Degas' portraits of himself bear out his determination to be a realist – which is what he had wished the name of the first exhibition of the Independent group to reflect. This painting is an unequivocal image of a self-satisfied, self-indulgent young man, lacking humour. But however convincingly he misrepresents himself (since he had a strong sense of humour, and was witty and hard-working), the pursed mouth suggests a supercilious nature that events later confirmed. As a portrait, it is brilliant, uncompromising and, as he himself wished it to be – honest. He is holding a drawing crayon which indicates an interest which at that time and despite his father's disapproval, was beginning to dominate his hopes for a future career. The quality of the draughtsmanship in so young a man, not yet 21, is astonishingly precise, sensitive and assured. He painted most of his self-portraits before he reached the age of 25.

PLATE 2
René-Hilaire De Gas (1857)
Oil on canvas, 20⅞ x 16 inches (53 x 41cm)

This portrait of Degas' grandfather was the result of a visit to Naples in 1856. He made a number of studies and drawings while there, and his grandfather's forbidding appearance is clearly delineated. It is likely that as his oldest grandson Degas would have been particularly cherished and despite the sour patrician look, the portrait indicates that Degas was afforded a great deal of time in order to study his grandfather. It is perhaps not unexpected that with his noble ancestry, René-Hilaire was unsympathetic to the Revolution, and two events must have reinforced his views. Firstly, his fiancée was guillotined after showing friendship to the Prussians and, if the story is true, he himself received a warning when he displayed sympathy for Marie Antoinette at her execution. In the event, he left France, went to Egypt and after an adventurous if sparsely documented period, settled in Naples, becoming first a corn merchant then subsequently founding the bank which became the source of the financial security that Degas enjoyed in his early years.

financial security. He had no need to follow a career and becoming a painter was born out of an intellectual passion for a cultured, creative life. Not for him the driven torment of Van Gogh or the romantic quest of Gauguin; indeed, on one occasion when asked whether he painted out-of-doors, *en plein-air*, he is reported as replying, 'Why would I, painting is not a sport.' Later in life he put this view more pungently: 'You know what I think of painters who work in the open. If I were the government I would have a company of gendarmes watching out for men who paint landscapes from nature. Oh, I don't wish for anybody's death; I should be quite content with a little bird-shot to begin with ...Renoir, that's different he can do what he likes.'

Hilaire-Germain-Edgar Degas was born on 19 July 1834 at 8 rue Saint-Georges, Paris, the son of the manager of the Paris branch of the private family bank owned by his grandfather, who then lived in Naples. His father was a cultured man with a passionate interest in the arts who had a considerable influence over his son's early development. His mother, Célestine Musson, was of Creole origin and came from New Orleans. (The Creoles of Louisiana were the French, Spanish or Portuguese descendants of settlers who retained their own patois and culture.) Although she died when Edgar was a child, the family retained its links with the town and Degas, late in 1872, went there for an extended visit which resulted in one of his most important early works, a painting somewhat out of context with his usual subject-matter, *The Cotton Exchange at New Orleans* (plate 15).

Degas was always a proud, reserved individual, something of a misogynist, conscious of his social status and with a sharp, witty tongue and cool temperament. His whole demeanour and background seemed to preclude an artistic career and his father, while encouraging his son's interest in the intellectual life of the capital saw him, in the true sense, as an amateur, that is to say a 'lover', of the arts, and was hardly sympathetic when he learnt of his son's wish to dedicate himself to painting. Of course, there was no financial necessity for Degas to sell his paintings and, like many artists, he had a distaste for commerce. He could not even bear to be parted from his works and clients buying his paintings quickly became aware of his habit of asking for them back in order that he could add some 'finishing touches', after which he sometimes failed to return the paintings to their owners. Most clients, growing wise to the practice, usually succeeded in recapturing their property on a subsequent visit; but there were many times when sharp words ensued, and there is at least one occasion of a painting never being returned. In his early 20s, Degas had so far identified himself in his comment: 'It seems to me that today, if the artist wishes to be serious ... he must once more sink himself into solitude.' Through

Continued on page 18

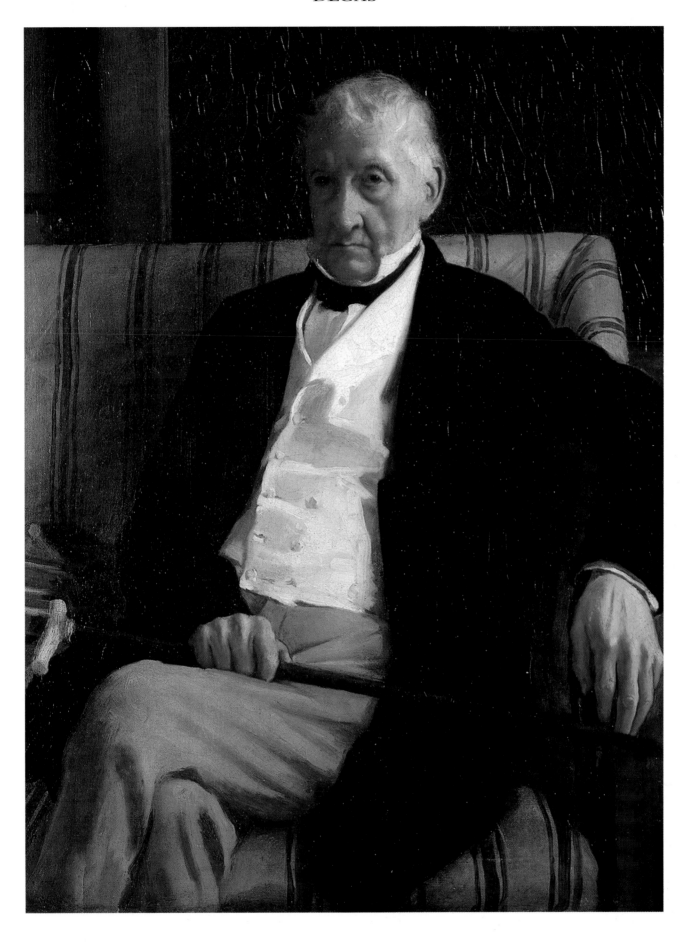

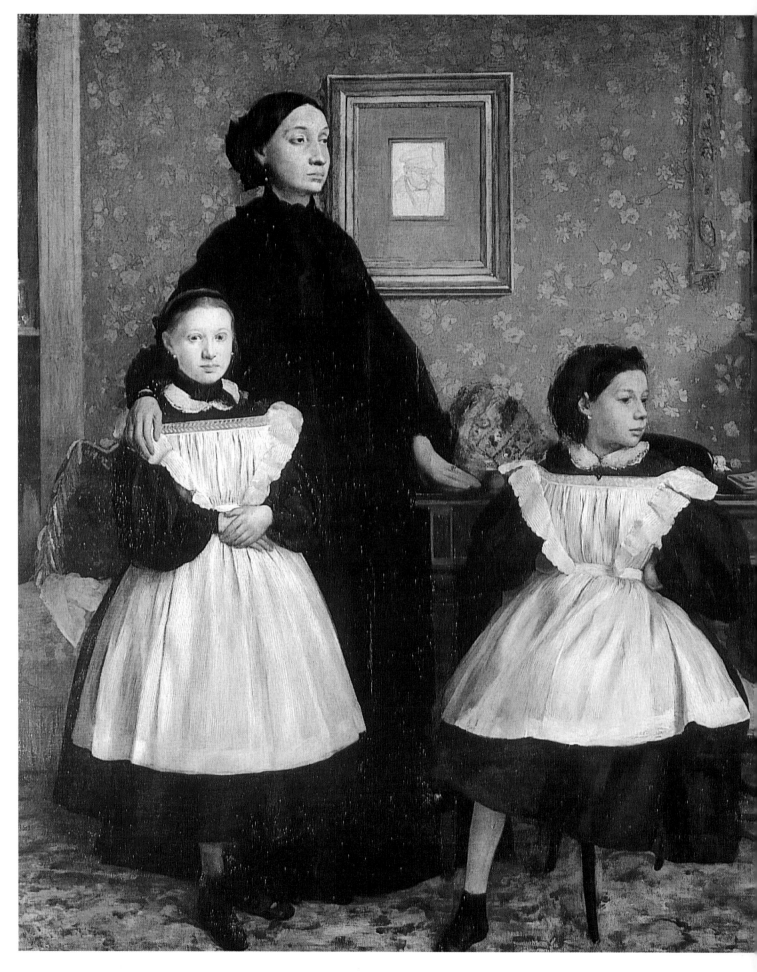

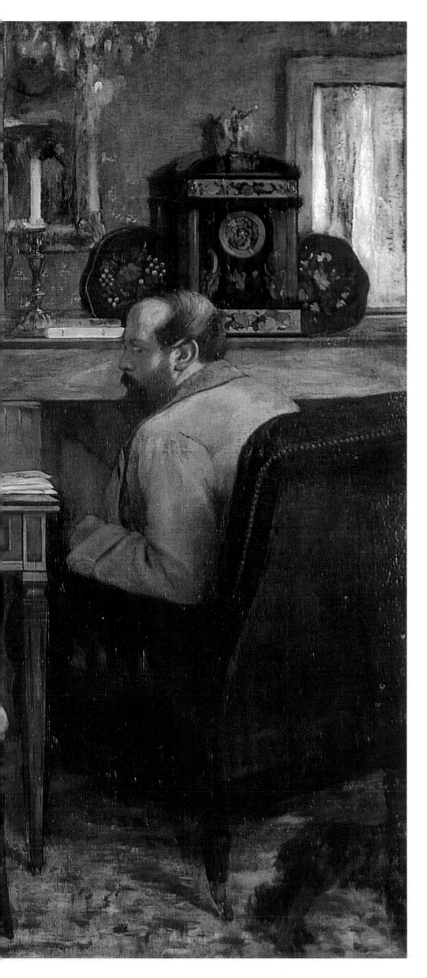

PLATE 3
The Bellelli Family (c.1858–60)
Oil on canvas, 78³/₄ x 98³/₈ inches (200 x 250cm)

Degas was very fond of his aunt Laura, his father's sister, and after leaving Rome was invited to visit her in Florence where she lived with her husband, Baron Gennaro Bellelli and their daughters, Giovanna and Giulia. It was Degas' original intention to paint his aunt and her daughters, but the painting eventually included Baron Bellelli, a decision which caused his father some concern since Gennaro was an unpredictable character. It was constructed from a number of separate sketches and completed in Paris. Degas' first composition was not entirely satisfactory to him and he returned to Florence to make more studies, including a full sketch of the intended composition. Back in Paris he completed the revised working during 1860. There are a number of unresolved questions posed by the painting, not the least being the identity of the significant, defining rectangular portrait in the background. Laura is wearing black as her father René-Hilaire had recently died and it is suggested that the work was intended as a memento mori. Another suggestion is that the background picture is of her brother Auguste, Degas' father, and a different interpretation is possible if this is true. However, the composition does break new ground in that it is an interpretation in modern terms of the familiar Renaissance family portraits which Degas much admired.

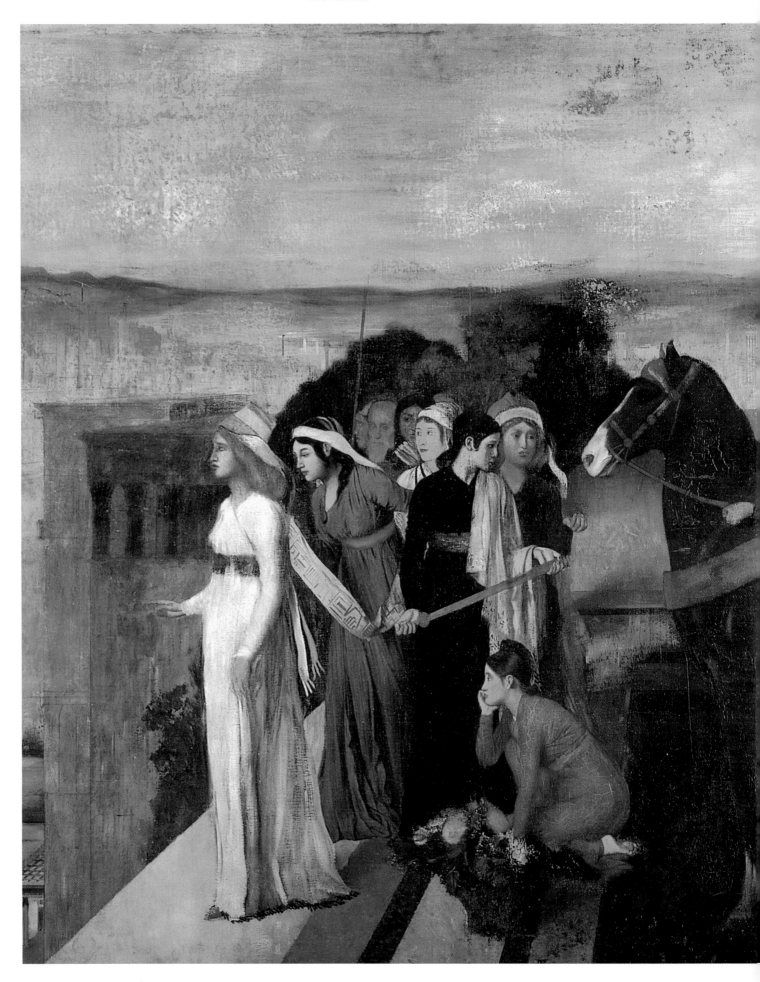

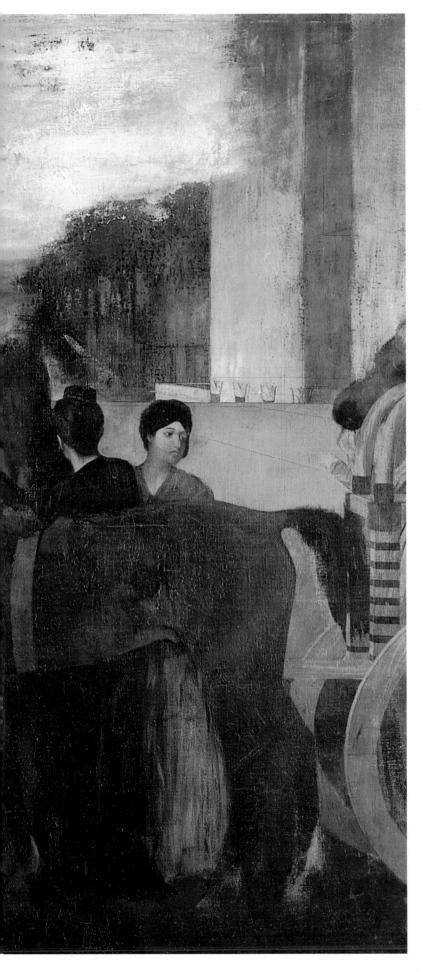

PLATE 4
Semiramis Founding Babylon (1861) detail
Oil on canvas, 59³/₈ x 101¹/₂ inches (151 x 258cm)

*Under the influence of Ingres and the academic tradition of
historical or mythological paintings, Degas made a number of
paintings or sketches for such subjects in the early years of his
development. The mythological Assyrian queen, Semiramis,
the wife of Nunus founder of Ninevah, was the most powerful
figure in the early stories of the building of the Assyrian empire,
including the whole construction of Babylon, the road system, the
conquests of Egypt, Ethiopia and Libya, and numerous other
feats. She was also a goddess, the daughter of the Syrian goddess
Derketo. She is Rossini's Semiramide and for some time it was
believed that Degas drew inspiration from this source since it was
performed at the Paris Opéra in 1860 and Degas was an opera
fan: this source of the painting is, however, now discounted. In
the academic terms then dominant, the painting is an attractive
and delicate example, constructed with great restraint. There is a
study drawing of the horse which shows the extraordinary
distinction of Degas' draughtsmanship, even at this early stage of
his career.*

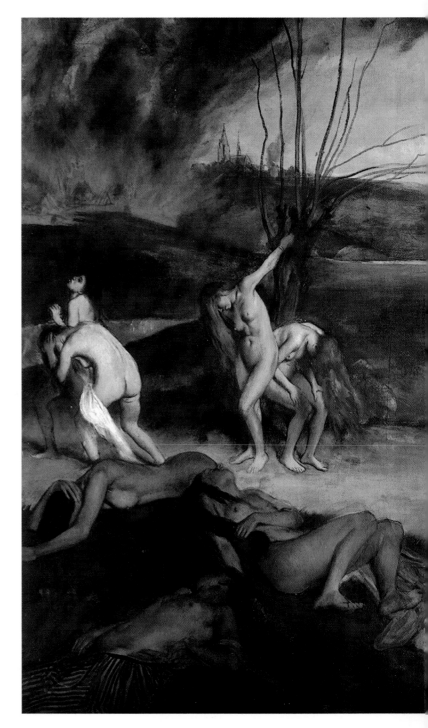

Continued from page 12

his life he was a solitary and towards the end was almost a recluse. (It is interesting to note that William Morris, the leader of the Arts and Crafts movement in England, was born in March of the same year as Degas.)

In 1845, at the age of 12, Degas entered the Lycée Louis le Grand as a boarder where he received a full classical education which naturally included the study of Greek and Latin. The lycée had a considerable influence on him: while there, he developed his life-long passion for the French classics, in particular the works of Racine, Pascal, La Rochefoucauld, Gautier and Flaubert, which, together with his classical training, fed his maturing intellect and complemented his original, questing spirit. His schooldays had another important effect on his later life in that while at the lycée he formed friendships with a number of his fellows which continued for the remainder of their respective lives. Notable among these were Henri Rouart and Paul Valpinçon, both of whom figured importantly in his later life.

In 1853, and in deference to his father's opposition to his becoming an artist, Degas entered law school although, once there, his lack of concern for his studies and his expanding interest in the arts were so compelling that he spent most of his time drawing, visiting the studios of artist acquaintances and the private collections of his friends while also studying for many hours in the galleries

PLATE 5

Scene of War in the Middle Ages 1865

(also known as *Les Malheurs de la Ville d'Orléans*)
Oil on paper, mounted on canvas, 33½ x 57⅞ inches
(85 x 147cm)

When one recalls Degas' devotion to 'realism', this painting is somewhat baffling. It might be remembered that Manet exhibited his painting, Olympia, which caused a scandal since it depicted a nude and suggested to viewers through its evident realism what

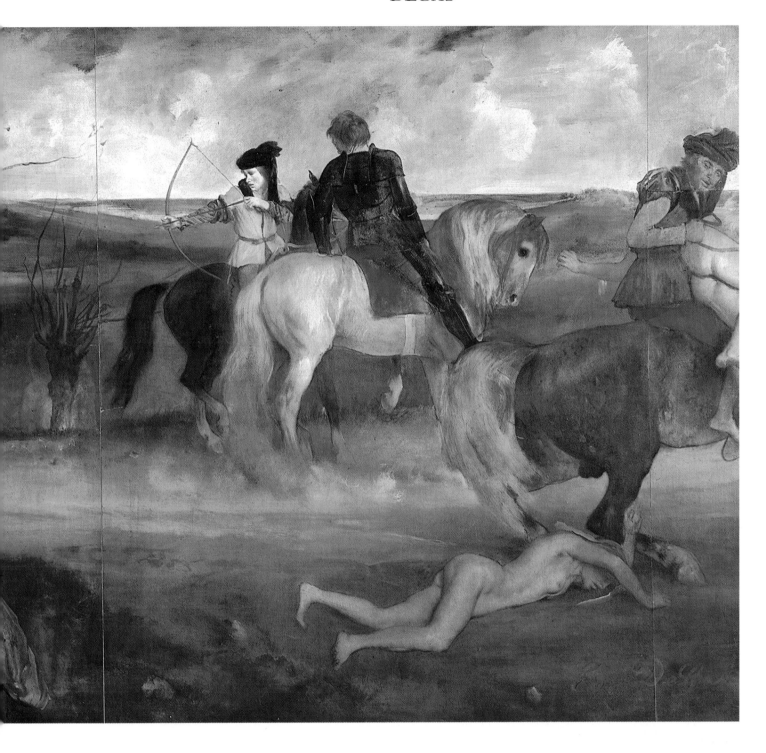

critics took to be proof that she was a prostitute. In this painting, included in the Salon of 1865, there are several nudes, realistically depicted with overtones of sexual violence. It will also be noticed that one of the executioners, herself a woman, is in the act of killing another woman in a way which looks very like sport to her. On the right there is part of the figure of a naked woman being abducted and there is undoubtedly a salacious content to the work. It is therefore reasonable to ask why this painting appears to have caused no offence? There is, too, some difficulty in interpreting the intention or subject. Until recently, the association

with Orléans was part of the title but no such event took place during the Middle Ages as far as is known. Of course, there may have been some association in Degas' mind with New Orleans, the American city from which his mother originated, but what this might have been is not known. This was the last of Degas' history paintings and it is interesting to note that he signed the picture bottom right, Ed. De Gas, his actual family name. The scandal caused by Manet's picture, Le déjeuner sur l'herbe, is considered on page 33.

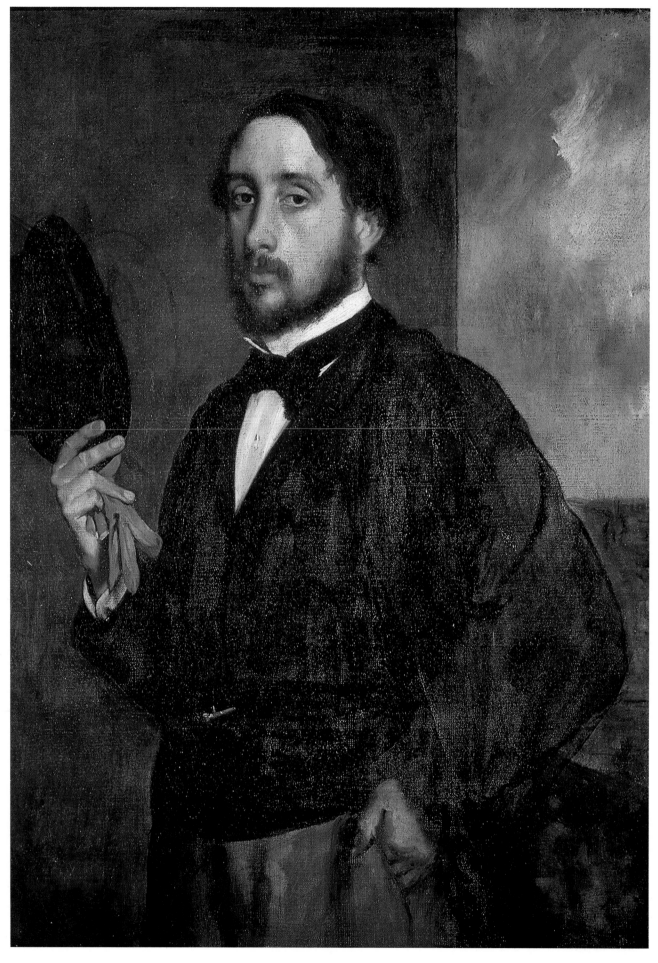

PLATE 6
Self-Portrait with Hat (1862)
Oil on canvas, 19 x 24¼ inches (48.5 x 61.5cm)

Although recognizably the same person portrayed in the self-portrait painted six or seven years earlier (plate 1), there is a supercilious assurance in the demeanour of the Degas of the later work. A comparison will indicate a subtle significant change in the eye-level used in the straightforward gaze on equal terms with the viewer in the earlier work to the slightly downward enquiring glance of the later – a slight but unmistakable reflection of a new awareness or assumption of his own superiority. One searches in vain in this picture for the Degas described by his peers as witty, charming and companionable. Could it perhaps then be a revelation of an underlying insecurity? The drawing of the hand and glove, acutely observed and carefully delineated, clearly reveals the influence of Ingres at the early stage of his career.

of the Louvre. He also enrolled in the print-room of the Bibliothèque Nationale where he made copies of great Renaissance masters such as Mantegna, Leonardo and Holbein. It was his habit to keep notebooks of his reactions and observations and in one from this period observed: 'Seek to blend the spirit of Mantegna's armour with the animation and colour of Veronese' – a prescient comment on the nature of his achievement; fine drawing with refined colour. Yet another: 'Painting is the art of surrounding a spot of Venetian red in such a way that it appears vermilion.' For Degas, the sum of these experiences of Renaissance art was to confirm a devotion to the classical spirit to which he had been introduced in early childhood and to reinforce an admiration for the Renaissance form of linear draughtsmanship which distinguished his work.

It was during this time, in the collection of Paul Valpinçon's father, that Degas first saw a number of works by Jean-Auguste-Dominique Ingres, recognized as the great academic successor of the Neo-Classicist Jacques-Louis David and himself acknowledged as a fine draughtsman. Soon afterwards Degas met Ingres and developed a reverence and admiration for the man then regarded as the greatest painter of the time, feelings which remained with him for the rest of his life; he never forgot Ingres' advice: '...draw lines, young man, draw lines; whether from memory or after nature. Then you will be a good artist.'

At the age of 21 Degas entered the studio of Louis Lamothe, a former student of Ingres; but the association was not a very happy or fruitful one. He finishes a letter to Gustave Moreau with the observation, 'Lamothe is more foolish than ever'. More profitably, he also studied at the École des Beaux Arts where he met other young and eager painters, including Léon Bonnat and Fantin-Latour, both later to become, with Degas, well known independent painters. It was at this stage that Degas began to acquire those qualities of draughtsmanship which are revealed for the first time in the many drawings he made of himself and his family. It should be remembered that during most of the 19th century, the normal method of study was to enter the studio of a recognized painter/master as an apprentice so that his period with Lamothe is nevertheless his first professional step.

Degas made his first of a number of visits to Italy in 1857, ostensibly to visit his grandfather in Naples and his aunt (his father's sister was married to a Baron Bellelli), but was perhaps as much drawn to the classical Latin culture that he knew he would encounter in Italy. In fact, from 1857 to 1860 he spent much of each year in Rome where a number of his old friends were then living and through whom he made a number of new friends. His deep interest in music was encouraged by his meeting there with Georges Bizet who was four years his junior and who had won the first Prix de Rome in 1857. Significantly, the most important meeting Degas made in Rome was with

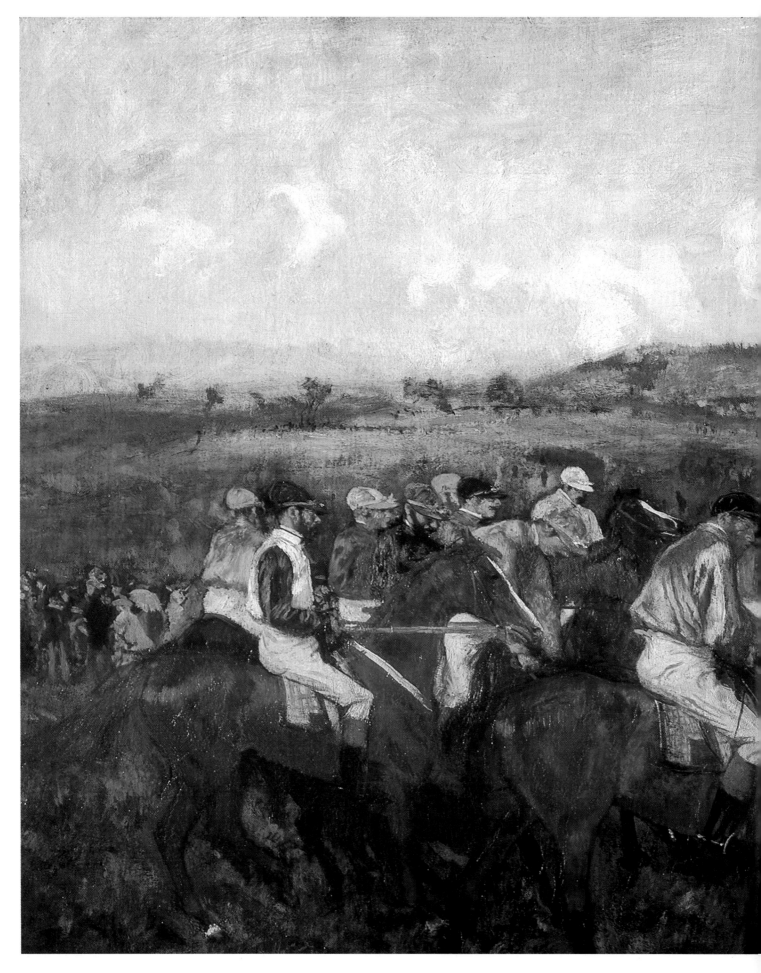

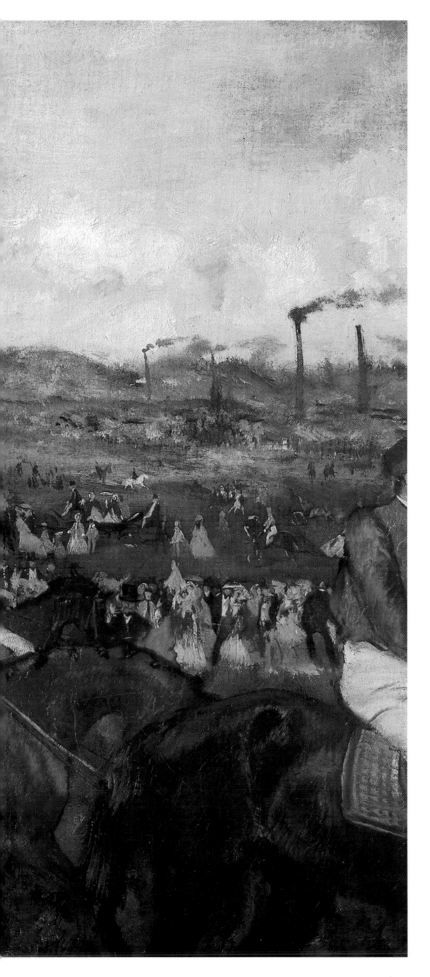

PLATE 7
Gentleman's Race: Before the Start (1862)
Oil on canvas, 19 x 24¼ inches (48.5 x 61.5cm)

Degas made the first studies of horses and racing subjects in 1861 and during the 1860s produced a number of studies and paintings of this 'sport of gentlemen' which, for Degas, was an appropriate interest for one of his level in society. Not surprisingly, these subjects were popular and their appearance signalled the end of his academic paintings without affecting the character or quality of his draughtsmanship. The title of this painting will indicate the riders' amateur status and the crowd in the middle-distance is clearly 'society'. Just to emphasize the point, perhaps, Degas has included the smoke stacks of industry – where the workers are! His interest in racing subjects was replaced by other concerns but his interest in horses remained and appears later in his work. (See also plates 8 and 9.)

Gustave Moreau who was there on a visit from Paris. Moreau was a painter raised in the academic tradition who favoured large biblical or classical subjects, treated with great attention to detail. He was highly intelligent and sophisticated and was recognized as an inspirational teacher. Temperamentally a Romantic symbolist with a highly developed sense of the mystical, through his widely ranging knowledge he introduced Degas to the Venetian Renaissance colourists, especially Titian. Moreau had also been working with Chassériau, a pupil of Delacroix, and through him directed Degas to the work of Delacroix, that painterly and colourful Romantic who in his early days had been an independent and had achieved a fame outside the Salon comparable to that of Ingres. Therefore, before 1860, Degas had been introduced to the work of the greatest painters of both the Classical and Romantic traditions, Ingres and Delacroix, and had absorbed much inspiration and food for thought from these two disparate but important figures.

Moreau, it is also significant to note, was a pastellist whose intense, brilliant colour had considerable effect on Degas' own unique use of the method, and in which he produced many of his finest works – particularly in his later years. It would not be an exaggeration to say that Degas was himself one of the finest of all pastellists.

During 1858 Degas made a long visit to his aunt in

Continued on page 29

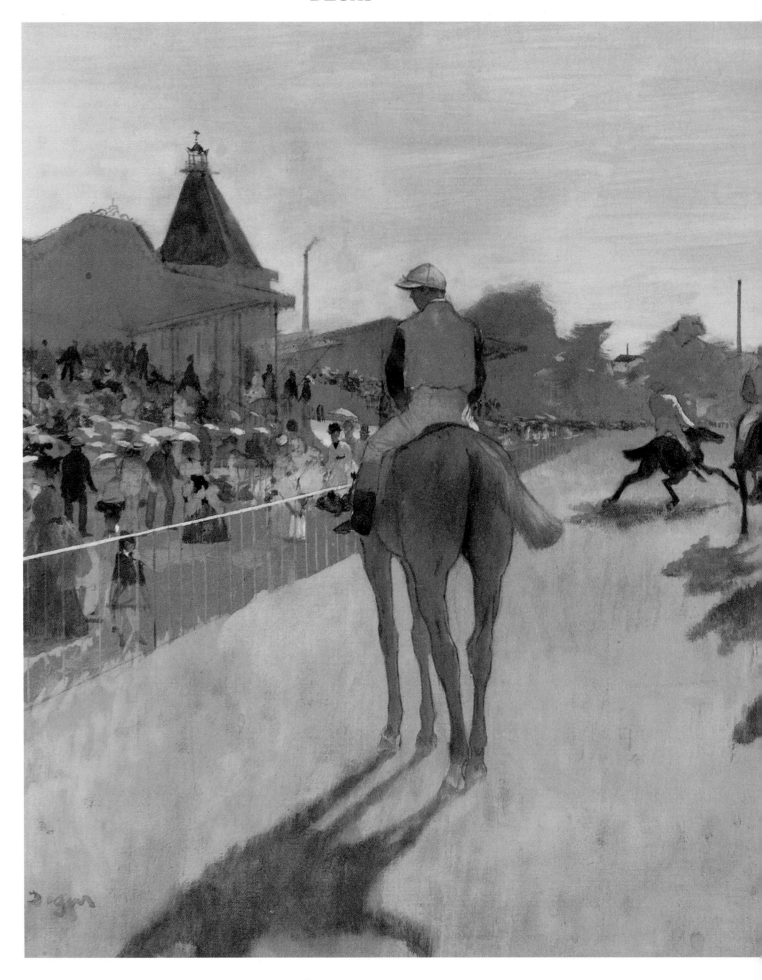

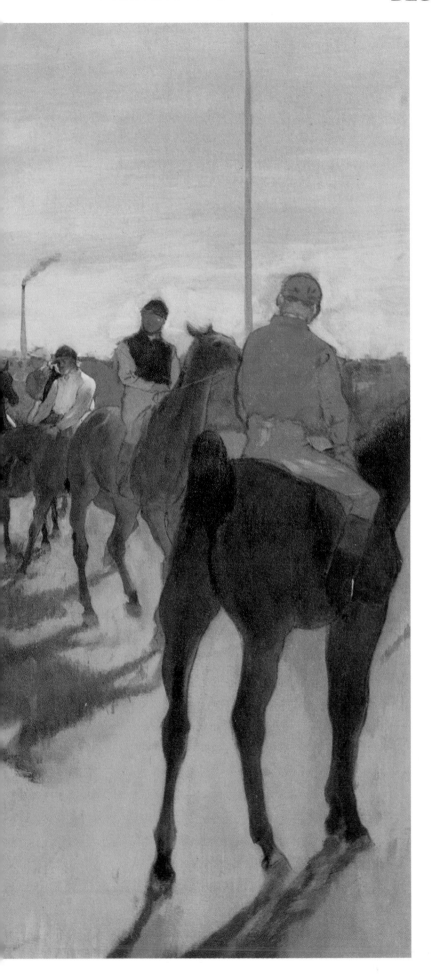

PLATE 8

At the Racecourse, with Jockeys in Front of the Stands (1869-72)

Essence on canvas, 18¹/₈ x 24 inches (46 x 61cm)

Degas and Manet, as befitted their upper middle-class image, frequented the races and both made paintings of racing subjects. For Manet it was the movement and bustle of the crowds and the speeding horses that interested him; for Degas it was the parade or the period before the race began. His images are clear and the drawing acutely observed. His unusual sense of colour and liking for sharp contrasts and highlights were especially catered for in the subject and most of his paintings offer unexpected compositional qualities. This painting, in essence not oil, is a study for a larger work and is lightly and thinly painted on a toned canvas. The running horse in the distance indicates that he had not yet seen the Muybridge photographs of horses running.

Degas used essence as a sketching medium since he wanted the effect of oil without the long drying time, and was easy to handle. Essence is the term used to identify a dried oil mixed with a volatile spirit, probably turpentine.

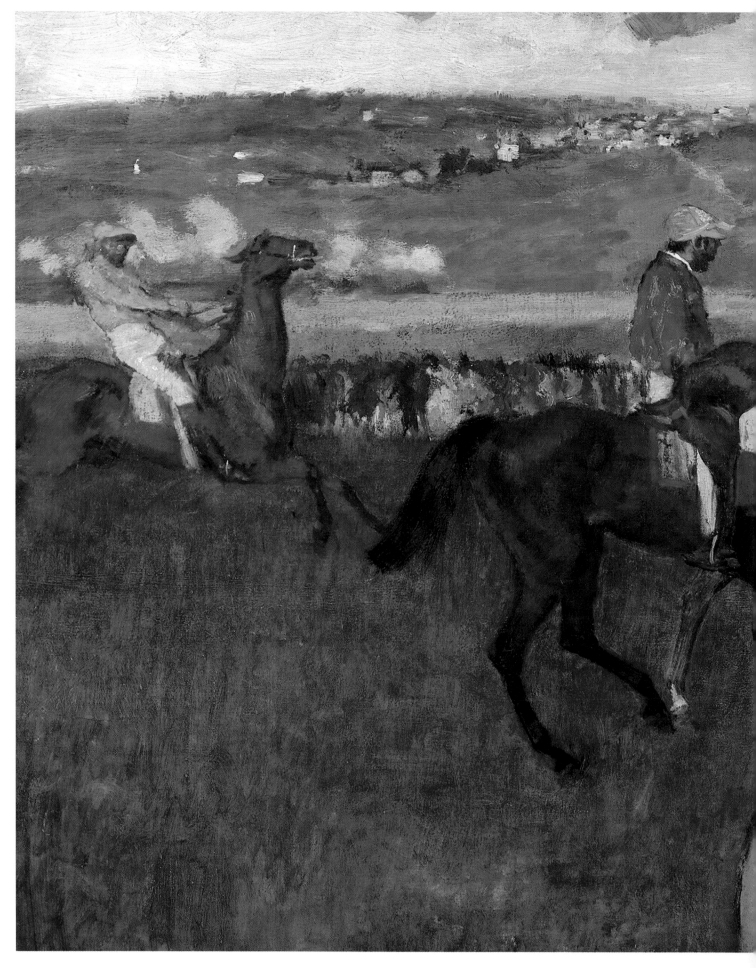

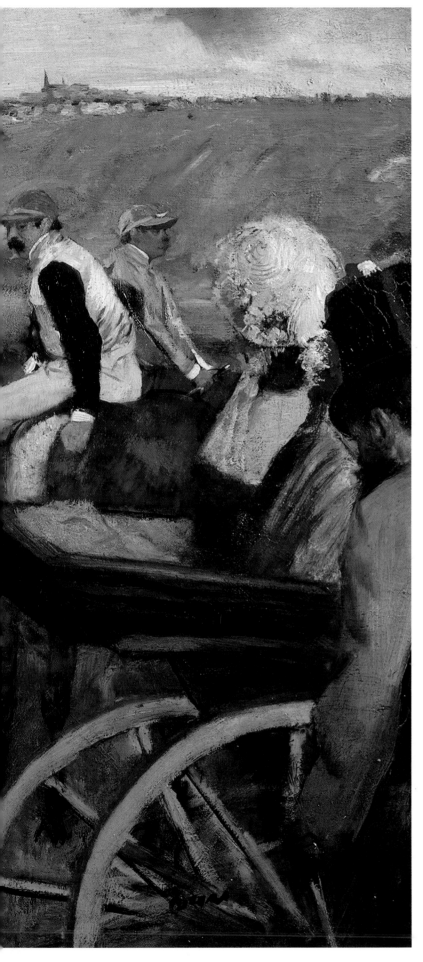

PLATE 9
Amateur Jockeys on the Course, beside an Open Carriage (c.1877)

Oil on canvas, 26 x 31⁷⁄₈ inches (66 x 81cm)

Degas' interest in racing subjects had declined by the mid 1870s but this accomplished painting with its bold compositional devices shows that he continued to find many aspects of the races attractive. This work, emphasizing the aura of privilege which surrounded much of 19th-century racing, reveals that the amateur jockeys themselves are part of the same social stratum as the carriage owners and are here seen hobnobbing with the ladies before the race. The composition is almost that of a photograph, a snap-shot image, since the focus of interest of the observer, the 'photographer', is concentrated on the jockey who looks to the left (at a friend?) and this results in the carriage being only partly seen, the main space in the frame being landscape. The naturalness of this compositional effect is characteristic of Degas and represents his real interest in photography.

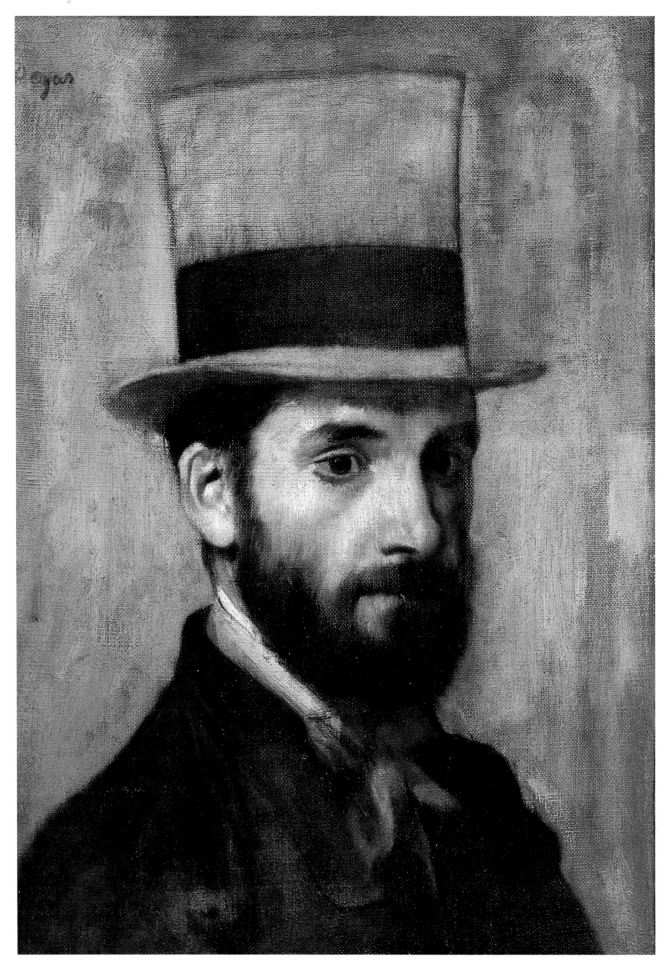

PLATE 10
Léon Bonnat (c. 1863)
Oil on canvas, 17 x 14¹/₈ (43 x 36cm)

It is probable that Degas met Léon Bonnat, who was one year older, at the École des Beaux Arts in Paris in 1855 and they certainly met in 1858 in Rome. Bonnat won the second Grand Prix de Rome and it was there that he met Degas who was one of a small group he joined. Bonnat later became a fashionable portrait-painter and a museum was created in his name in his native city of Bayonne after his death in 1922. Degas described him as 'nice and an old friend', although he did not greatly admire his painting. Bonnat was one of those friends that Degas painted while he was still an amateur and not receiving commissions or using professional models.

Continued from page 23

Florence. Here he made numerous studies of members of the family – notably his two young female cousins – and used them on his return to Paris to produce his first group portrait in oils (plate 3). This effectively determined his own private, personal and professional attachment to art. Of his feelings and character, his own travel notes are often revealing. 'I am now going back to the life of Paris. Who knows what will happen? But I shall always be an honest man.'

This return happily coincided with the new influences becoming apparent in Degas' work. He became aware of Japanese prints which were then beginning to appear in France after the opening of trade with Japan in 1854. These were sometimes used to wrap small imported objects. Degas was a friend of Félix Braquemond, an engraver, who in 1856 had discovered the prints of Hokusai and introduced Degas to his work. Japonaiserie became the vogue in France during the 1860s, later popularized by the Oriental Pavilions in the Universal Exhibitions of 1867 and 1878. Many artists, particularly those outside the restrictive academic world, were attracted to aspects of oriental art. Whistler was perhaps the most enthusiastic follower of the fashion, but Monet discovered a clarity in the prints and Manet recognized the strong tension existing between light and dark oppositions. Both incorporated something of these elements in their own work, without becoming overtly orientalist. Degas, on whom the influence was possibly the most subtle, was impressed by the compositional qualities that seemed innovational – figures non-centralized, asymmetrical and foreshortened as well as figures cut by the borders and brought close to picture plane to create an intimate direct association. Their unfamiliar character and composition, offering a new and original visual imagery, had a considerable impact on many artists in the middle and late years of the 19th century and for Degas had a positive effect on his compositional methods.

Perhaps even more significant for Degas was the advent of photography. A number of painters saw it as a threat to their exclusive ability in the field of visual representation which was, for many, the principal or only artistic justification. One well known painter, Paul Delaroche, is recorded as commenting on sight of his first photograph, 'From today painting is dead'. For Degas, however, it was both an aid and an inspiration. He saw photography as providing visual information not readily available (particularly in respect of human and animal movement) as well as, in 'snapshot' views, offering original compositional solutions (see plate 9). In later life, Degas' interest became a passion at least partly inspired by his seriously deteriorating eyesight, photographs providing a record of a model or other subject from a necessary distance that he would otherwise have been unable to capture. There is a story of

PLATE 11

Thérèse De Gas (c. 1863)

Oil on canvas, 35 x 26⅓ inches (89 x 67cm)

Thérèse was Degas' sister and eight years his junior. She married Edmondo Morbilli, her cousin and a member of a noble Italian family (he was Duke of Morbilli), in 1863. During the early period of his career, before the failure of the family bank, Degas painted a number of portraits of family and friends since he was not at that time a 'professional' painter. (That is only to explain that he did not then make a living from painting and is not a comment on the quality of his work.) He painted these portraits to further his own experience. However, the distinction of the paintings was attractive to all his sitters. One quality always present in his work is an individual sense of colour and the use of the sharp pink ribbon bow is a good example of its heightening effect on the whole painting. It may be noted that the painting has suffered some damage.

his leaving a dinner-table to fetch his camera so that he could pose all the guests for a composition to be completed later.

A CHANGING WORLD: ROMANTICISM AND REALISM

Degas became involved with the Parisian art scene during a period of profound change. The French artists of the establishment, the academicians, the students in their ateliers and the artistic *haut monde* relied for their authority and standards on the accepted masters of the day and their work as displayed in the annual Salon, held in the Grand Salon of the Louvre Palace. The recognized great master of the day was Jean-Auguste-Dominique Ingres, inheritor of the mantle of Jacques-Louis David – Neo-Classicism – which, as its name implies, looked back to classical Greece and Rome (particularly Rome) for both subject-matter and style. It inspired a careful evocation of Roman architecture and, in painting, a hard precise delineation of form as well as the use of classical sources for its subject-matter. For the first half of the 19th century, it was the basis of all academically acceptable painting and was the form adopted in most painting submitted to the Salon each year.

Early in the century, though not yet acceptable, an alternative was gestating. The English poets, Shelley and Byron, were looking to other, more imaginative and less timeworn sources, and in French painting a new and opposing reputation was coming to be recognized in the work of Eugène Delacroix, paralleled in England with that of John Constable and J. M. W. Turner. By the time that Degas was beginning to be a serious painter, this whole Romantic development had already engaged the interest of a number of young painters for whom the whole classical establishment was genuinely distasteful. Their somewhat reluctant leader was the painter Manet, and their rendezvous was the Café Guerbois in Montmartre, Paris.

Degas' probable first meeting with Édouard Manet occurred in about 1860. Manet came from the same social background as Degas and had become a painter with the hope and expectation of academic success and public recognition, at the very least rewarded with the Légion d'Honneur. But his independent nature had led him, despite his aspirations to success in the Salon, to explore a range of subject-matter and technique which, by the early 1860s, had led to his involvement with the avant garde, anti-academic group which joined him at his favourite 'waterhole', the Café Guerbois. This was partly the result of the *succès de scandale* Manet had achieved in 1863 from an unexpected and surprising source.

Beginning in 1833, a major artistic event of the Parisian social calendar was the Paris Salon which it was intended should be held every year in the Grand Salon of the Louvre (hence its name). It was opened in 1863 by

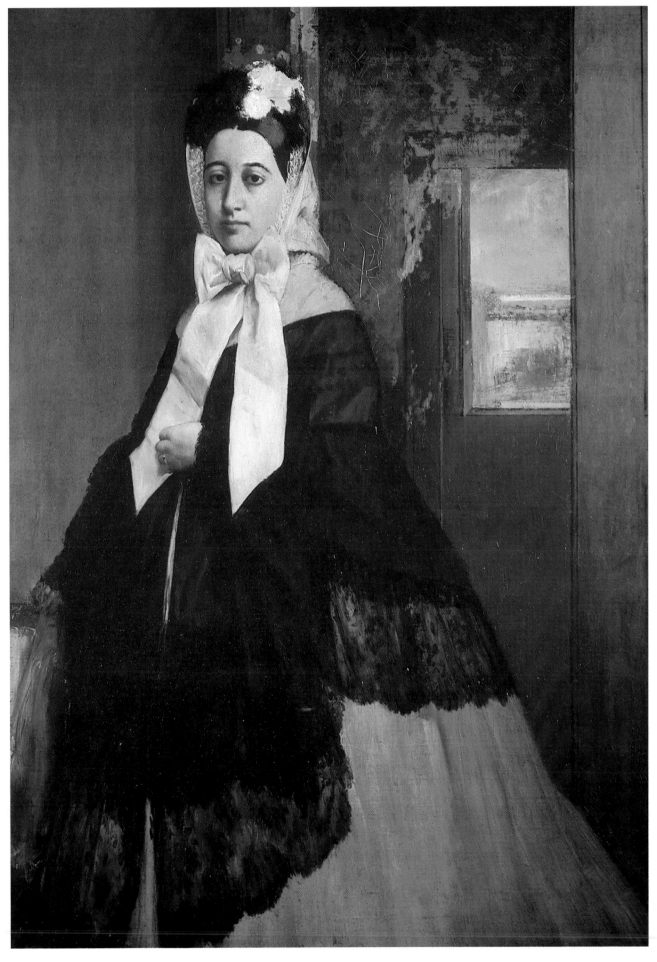

PLATE 12

Interior Scene, known as The Rape

(c. 1874 or 1868–69) detail

Oil on canvas, 31⁷⁄₈ x 44⁷⁄₈ inches (81 x 114cm)

A number of literary sources have been suggested as the origin of this picture. In the late 1860s and throughout the 1870s, Degas painted a number of genre works of a domestic kind, often taken from the works of contemporaries like Zola and his friend Duranty. No source has been definitely established although Zola's Madeleine Ferat seems a strong candidate. The composition is unusual and effective. Bearing in mind the tendency to read from left to right, the fact that the girl is not dressed for a social occasion is the first element observed and the eye then swings across an open space of pretty wallpaper and a bed to the reason why she crouches, unhappy and seemingly unaware of the man looking at her with careless disregard. It is an illustration and a story well told but not one of the typically Degas paintings. It was accidentally damaged and had to be repaired and retouched by Degas with the help of a painter friend in the early 20th century when Degas' sight had seriously deteriorated.

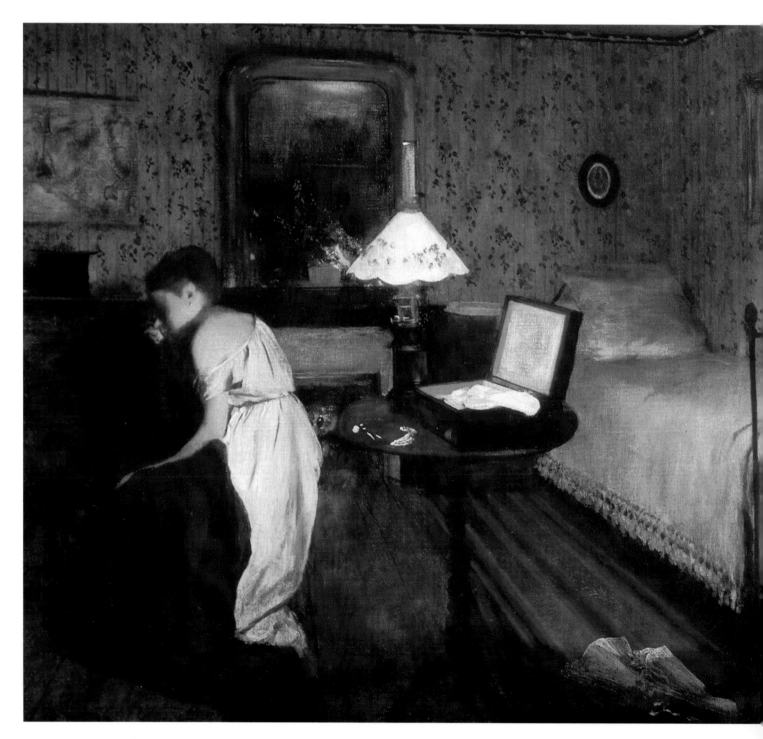

Napoleon III who suggested that to emphasize the superior quality of the pictures that had already been selected, those rejected by the judges should be shown in other unused galleries of the Louvre to be known as the Salon des Refusés. Although a number of independents, including future Impressionists Monet and Pissarro had been accepted for the Salon, Manet's painting, *Le déjeuner sur l'herbe* (Picnic in the Park might be a possible translation) was rejected and hung with the *refusés*. It was greeted with a barrage of hostility: Napoleon III, on opening the exhibition was said to have insisted that his wife avert her eyes from the picture. The experiment was not repeated, although similar unofficial Salons were organized in future years. Manet, admittedly somewhat obliquely, was following advice he had received from Courbet and Baudelaire to produce a painting of modern life. *Déjeuner* depicts two stylishly dressed gentlemen reclining on the grass accompanied by a naked female who looks nonchalantly and with idle curiosity directly out of the picture at the viewer, thereby establishing the voyeuristic involvement of every observer of the somewhat risqué scene. In the background of the painting another female figure is seen in a state of 'sweet disorder of the dress'. It was Manet's attempt to translate a composition from Raphael made into an engraving by Marcantonio Raimondi which, it is believed, Manet had previously seen. It was certainly a far cry from the original and although the poses of the figures were similar to those in the engraving, it was a scandalous interpretation which genuinely shocked its viewers. When Manet repeated the offence two years later with his painting of a reclining nude, *Olympia*, which also boldly and invitingly engaged the viewer's attention and which was somewhat surprisingly accepted by the Salon, he became the leader of the anti-academic independent painters who were

Continued on page 39

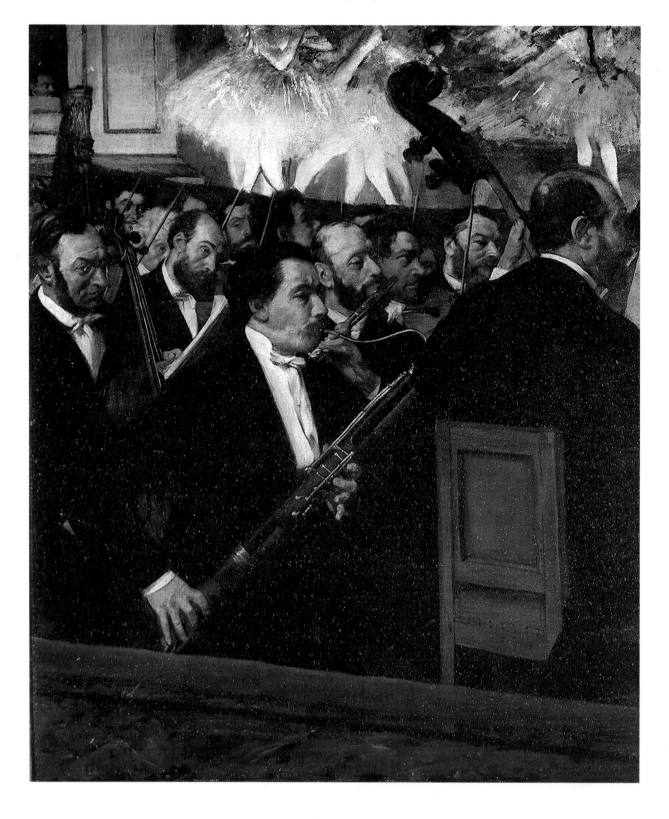

PLATE 13
The Orchestra of the Opéra, Rue Le Peletier (1868–69)

Oil on canvas, 22¼ x 18⅛ inches (56.5 x 46.2cm)

Visitors to Paris during this century will think of the great building by Charles Garnier as the home of Parisian opera in the Place de l'Opéra, or would have done until the new Opéra Bastille was built and the other became the Opéra Garnier. But the opera house that Degas depicted in most of his paintings of the ballet was the much earlier building in the rue Le Peletier, destroyed by fire in 1873. Garnier's building, begun in 1861 was not completed until 1875. The Opéra Peletier was very convenient for Degas who lived nearby and usually visited the Opéra at least three times a week in his early and middle years. His painting of the orchestra which contains portraits of known musicians and includes the composer Chabrier (far left in the stage box), was his attempt at a group portrait and to make a decorative arrangement of musical intruments. In 1870, Degas gave the painting to the bassoonist Désiré Dihau (the central

figure) in gratitude for Dihau's introducing him to the world of the orchestra; Degas' family, in a roundabout way, also expressed their gratitude to Dihau since by keeping the painting away from Edgar, a finished work was achieved − Degas always felt that more could be done to any painting.

PLATE 14
Jeantaud, Linet and Lainé (1871)

Oil on canvas, 15 x 18⅛ inches (38 x 46cm)

Jeantaud, Linet and Lainé were friends of Degas who also served with him in a battery of the National Guard commanded by Henri Rouart during the Siege of Paris.

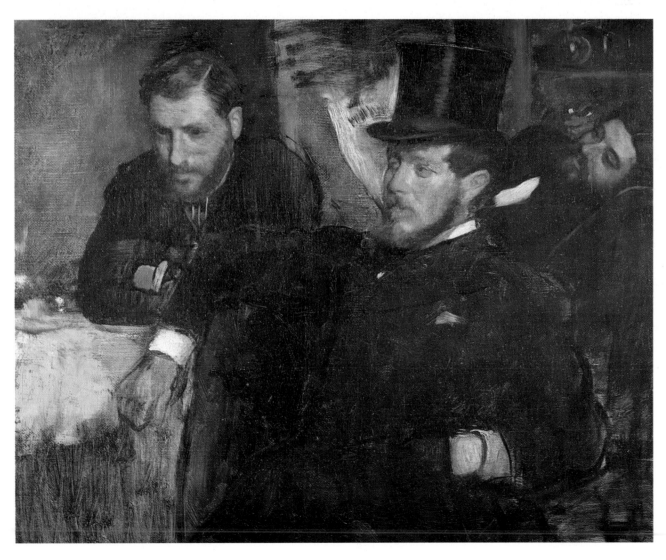

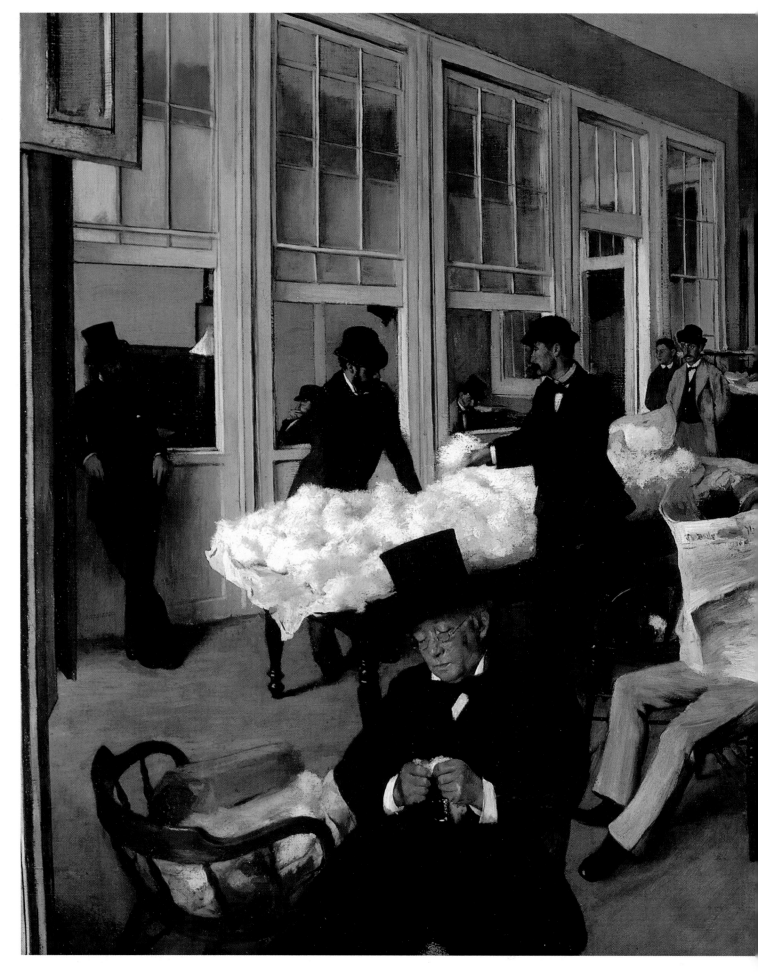

PLATE 15

The Cotton Exchange at New Orleans
(1873)

Oil on canvas, 28 x 36¼ inches (71 x 92cm)

In 1872 Degas made a visit to New Orleans and to René, his brother, who was a cotton merchant in partnership with another brother, Achille, and which gave him an opportunity to meet other members of his family. During the visit he also made studies for this painting which he finished on his return to Paris in 1873. René appears in the picture, reading a local newspaper, the Times Picayune *– possibly an indication of Degas' view of his brother's lack of industry before René's financial difficulties had emerged. Another member of the family, René's father-in-law, Michel Musson, appears as the old gentleman testing samples in the foreground. Achille, equally uninvolved in work, is seen leaning on the window on the left. The painting is another example of the* genre *paintings that Degas was producing in the 1870s, including* The Pedicure *(plate 16).*

One of Degas' devices, influenced by his photography, is to introduce a steep perspective in the foreground, thus accomplishing two effects – involvement of the viewer and at the same time identifying a deep recession. The casual atmosphere is deceptive: the oppositions of black and white are carefully distributed over the picture plane and balanced by cool green and warm ochre. The painting was sold to the museum at Pau in 1878, one of the first works of Degas to appear in a museum.

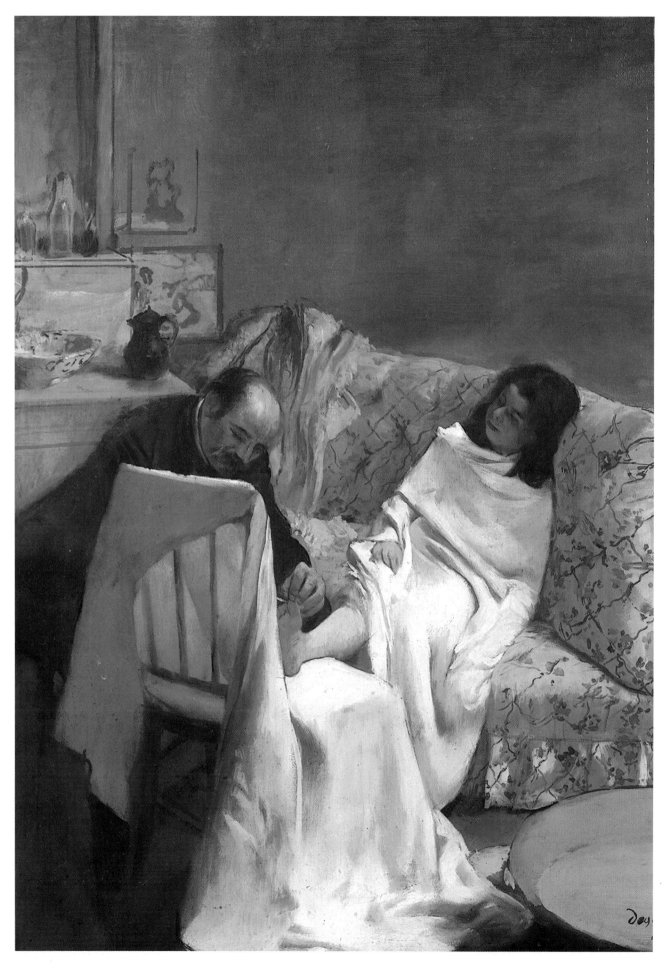

PLATE 16
The Pedicure (1873) detail
Oil on paper mounted on canvas, 24 x 18¹/₈ inches
(61 x 46cm)

An unusual subject in the Degas oeuvre, this was painted after his return from the visit to New Orleans from sketches made while he was there. It is suggested that the model was probably Joe Balfour or Bell, his brother René's stepdaughter by Estelle Musson whose first husband had been killed in the American Civil War. It is an example of an approach to subject-matter that was developing in Degas' work; an unusual and intimate angle seized at a crucial moment and seen at its fullest much later in the intimate Bathers series (see plates 35–38). It was one of the paintings taken by the Louvre Gallery from the Camondo legacy.

Continued from page 33

dismayed by the predominating and, as they thought, irrelevant historicism of most of the work of the Salon.

By 1865, Degas had become Manet's friend and a participant in Café Guerbois society which included Zola, Renoir, Monet and the critic Edmond Duranty (plate 29) who became Degas' friend, admirer and promoter. Although Degas, with his classical education and devotion to Ingres (who was still alive) was not in sympathy with much of their thinking, his association with these independents nevertheless links him to the beginning of what later became the Impressionist revolution. It is important at this point to consider what this was and what part Degas played in its formation and development.

The main complaint that both of Manet's paintings had provoked arose from the fact that the starkness of the nudity had been unrelieved by the usual associated classical trappings. The effect had been to introduce a new and disturbing realism into the rarefied and privileged world of art which was then the almost exclusive preserve of the so-called intellectuals, the rich and the aristocratic. The eroticism now discernible in much 19th-century academic work was to the artistic world of the mid 19th century (particularly in France and England) merely the proper form of expression of the classically-inspired subject-matter. The fact that Manet had actually reinterpreted Renaissance subjects in a modern context had not been recognized and even if it had been, his translation from the historical to the present would almost certainly still have resulted in his work being rejected by the establishment. On the other hand, the attention of young, questioning painters was directed to portraying modern subjects although, at this time, in traditional tonal painting techniques.

There were a number of precedents for this change. While classical themes were the most evident elements in the work of Ingres who painted a number of works that show a marked Romanticism (for example, interiors of Turkish harems), it is probable that only his loyalty to his master J.-L. David prevented his further exploration of exotic themes. His Romantic counterpart, Delacroix, had no such inhibitions and had travelled in North Africa, making sketches of Arab subjects which he translated into large compositions. These works, and those of other Romantics such as Géricault, with his painting *The Raft of the Medusa* – a naval scandal – had by the 1860s introduced a new atmosphere of freedom and experiment as well as non-historical subject-matter. There was a new realism also evident in the works of Courbet, the Barbizon painters who worked near the Forest of Fontainebleau, Boudin and the Dutch landscapist Jongkind.

However, it was soon realized by Manet's followers that he was also pursuing a new method of painting, a more appropriate technique, more modern. It was directed

PLATE 17
The Dancing Class (c. 1874) detail
Oil on canvas, 33½ x 29½ inches (85 x 75cm)

Precise dating of many of Degas' paintings is difficult since most were made from sketches made at the time of the event and then subsequently incorporated in the final work. In the ballet works during the early 1870s, it is important to remember that the performances or locations are identified as at the Opéra. As mentioned earlier, the old Opéra was in the rue Le Peletier and was burnt down in 1873; the new Garnier Opéra did not open until 1875. It is probable that this painting was executed during 1874 after the fire, but before the Garnier. It is, however, depicted as being in the Peletier Opéra where the rehearsal rooms

were in the elaborate style illustrated here. There is a very similar composition, including the dancing master in the same pose, which was painted in 1876 and located in the Garnier Opéra where the architecture in the rehearsal rooms was rather simpler.

Degas did a number of drawings and paintings of the dancers portrayed in their different poses. The dancing master, Jules Perrot, once Taglioni's partner as dancer and later a competent choreographer, was a well regarded teacher. This work is one of Degas' finest treatments of the subject and he handles the composition with his usual ingenuity and authority. Characteristic of his treatment of the dancers is the use of brightly coloured sashes, used here to great effect. Note again the steep perspective and the light touches of the small dog and watering can in the foreground.

towards finding a method of projecting a more immediate sense of actuality without 'factual' copying. It could be said, although at this time it was not, that their aim was to create a calculated 'impression' of a scene or other subject.

At all events, these young 'independent' painters in 1874 organized an exhibition which opened on 15 April at the former studio of the great early photographer Nadar and called it the 'Première Exposition de la Société Anonyme des Artistes, Peintres, Sculpteurs, Graveurs'. Degas was prominent among the organizers and exhibited with Monet and Renoir and other potential Impressionists. Among the exhibits was a painting by Monet called *Impression: Sunrise,* the title being immediately borrowed by the critic Louis Le Roy as a heading for his review, 'Exhibition of the Impressionists'. This resulted in the perpetuation of the name used to identify these young painters. Degas himself disliked the title, preferring the word independent although he would have approved of the use of 'realist'. He never described himself as an Impressionist.

Degas' career during the later 1860s consisted of work submitted to the Salon, sometimes accepted but more frequently rejected, so that in 1870 he gave up altogether. In 1865, in the same Salon as Manet's *Olympia,* he showed *Scene of War in the Middle Ages* (plate 5), a typically academic and historicist work influenced by Ingres and part of his then current programme of historical paintings

which he abandoned the next year. His painting *The Wounded Jockey,* in the 1866 Salon, indicated a new interest in horses and racing and two years later he exhibited a painting *Mlle. Fiocre in the Ballet La Source,* the first evidence of his growing passion for the theatre and ballet.

The Franco-Prussian War of 1870 was the beginning of a dramatic disruption of the cultural life of Paris and to the dispersal of writers and artists in response to war conditions. Characteristically, Degas and Manet remained in the city, joined the National Guard, and played a part in the Siege of Paris; Degas in a gun battery which, to his delight, included his two boyhood friends, Paul Valpinçon and Henri Rouart, who was the battery commander. However, as a result of exposure to cold weather while in the gun emplacements, Degas developed an eye condition which worsened steadily and affected him for the rest of his life, leading eventually to near-blindness.

As already mentioned, in 1872 Degas made a visit to New Orleans to his brother, René, a cotton merchant. He stayed from October to April the following year, during which time he made many family studies and from which, on his return to Paris, he painted his famous *Cotton Exchange at New Orleans* (plate 15). On his return, he moved to a new studio at 77 rue Blanche, frequented the Opéra, and met his friends at their new meeting-place, Café de la Nouvelle-Athènes, where they were joined by the painter Forain and the Irish writer, art observer and

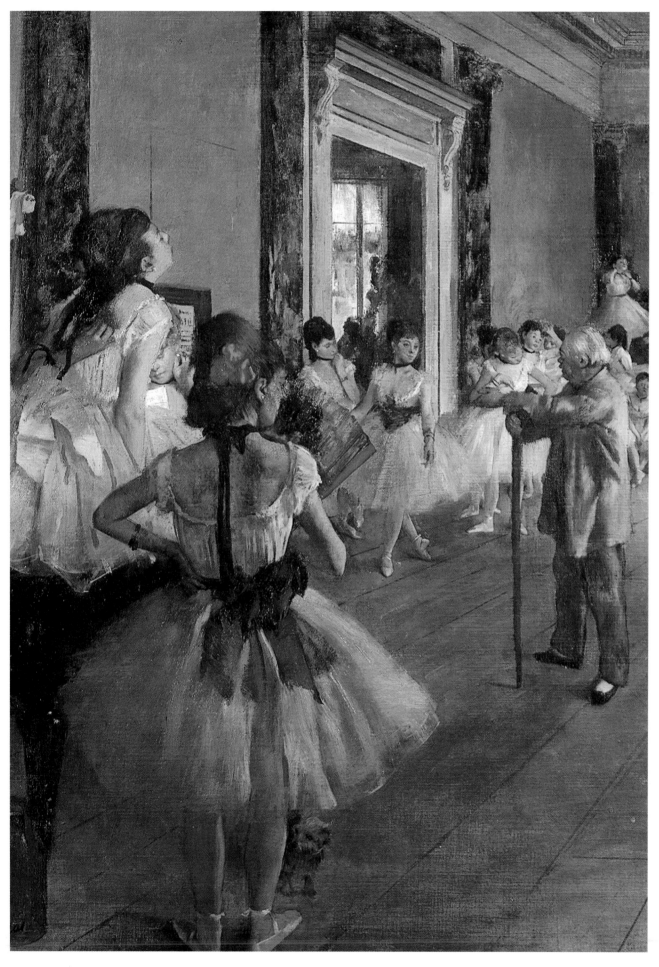

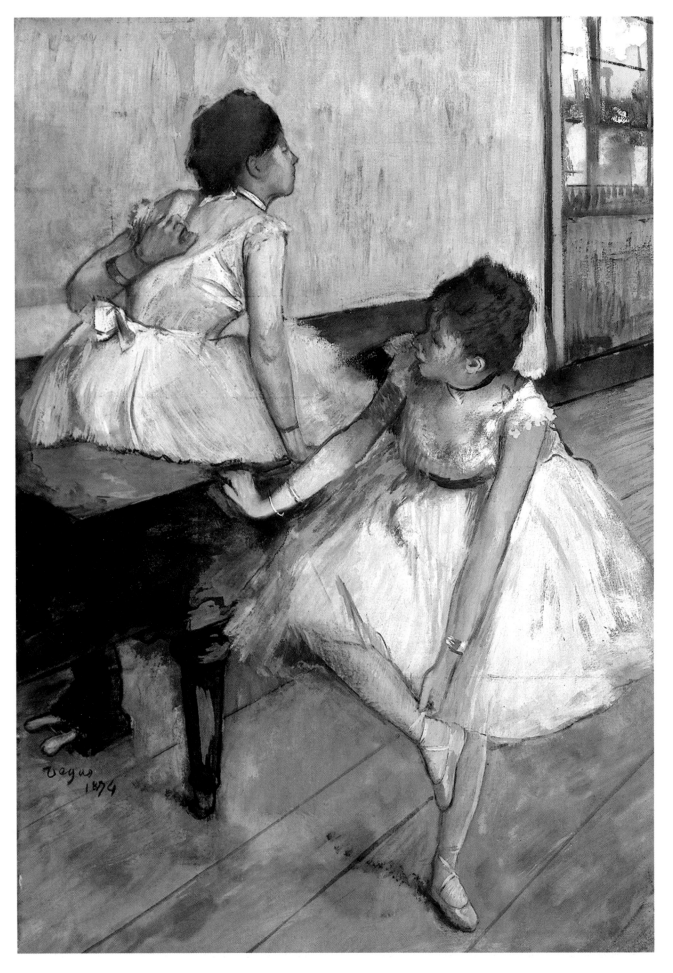

PLATE 18
Dancers Resting (1874)
Oil on canvas, 33½ x 29½ inches (85 x 75cm)

Degas spent much of his time either in the wings of the theatre or in the rehearsal rooms, making studies in charcoal, crayon or pastel of dancers working or at rest and repeated the poses in different paintings which, incidentally, was the common academic practice; a critically approved pose in a Salon work would be repeated in the next Salon submission. Both the poses shown in this painting are repeated in other works; indeed, the girl scratching her back appears in the previous plate sitting on the same piano.

critic, George Moore, whose perceptive remarks on his painter contemporaries provide us with some of the most evocative word portraits that exist. Moore describes the scene at the Nouvelle-Athènes: Manet '...sits next to Degas, that round-shouldered man in a suit of pepper and salt. There is nothing very trenchantly French about him either, except the large necktie; his eyes are small, and his words are sharp, ironical, cynical.'

In December 1873, Degas visited his father who was seriously ill in Turin and who in February of the following year died in Naples. His father's death revealed that the bank he controlled was in considerable financial difficulties and Degas as the eldest son felt a responsibility to take charge of the disturbing, near-disastrous situation. When he appealed to his brother René for help, he discovered that René was himself in difficulties and also needed financial assistance. Degas' secure life was at an end: to help settle the debts he was obliged to sell most of his important and valuable collection of paintings, including some fine pastels by Quentin La Tour, one of the greatest pastellists of the 18th century.

Not unexpectedly, this disaster changed the whole pattern of Degas' life. In Renoir's view: ' ...if Degas had died at fifty he would have been remembered as an excellent painter, no more: it is after his fiftieth year that his work broadened out and that he really became Degas.' From now on he would have to abandon his former

somewhat dilettantish existence and work as a professional painter, depending on the sale of his work for an income. It is hardly surprising that he found this an uncomfortable and depressing prospect. It should be remembered that commercial galleries and professional picture-dealers did not then exist as they do now, and the painter was obliged to sell his own work, either from his studio or from a private room. Degas' reserved nature and lingering pride in his superior social status rendered him so self-conscious, distressed and awkward with his customers that relationships with them, and even with his friends, often became acrimonious. He was also suffering increasingly from eye trouble which did little to improve his temper; many believed that, as is commonly the case, he often exaggerated his disability.

It was a time of great difficulty. While Degas' financial affairs took up most of his time, he still managed to be one of the prime movers, with Monet, in setting up the first Impressionist exhibition in 1874. This was the beginning of an interrupted series of eight exhibitions organized by the group, but known by different names. A second Impressionist exhibition took place in 1876, with the last in 1886, and Degas exhibited in all but two of them.

It is clear from this that Degas was closely associated with the development of what we now call Impressionism and it is certainly a common perception that Degas was an Impressionist. It is important in any assessment of his art to

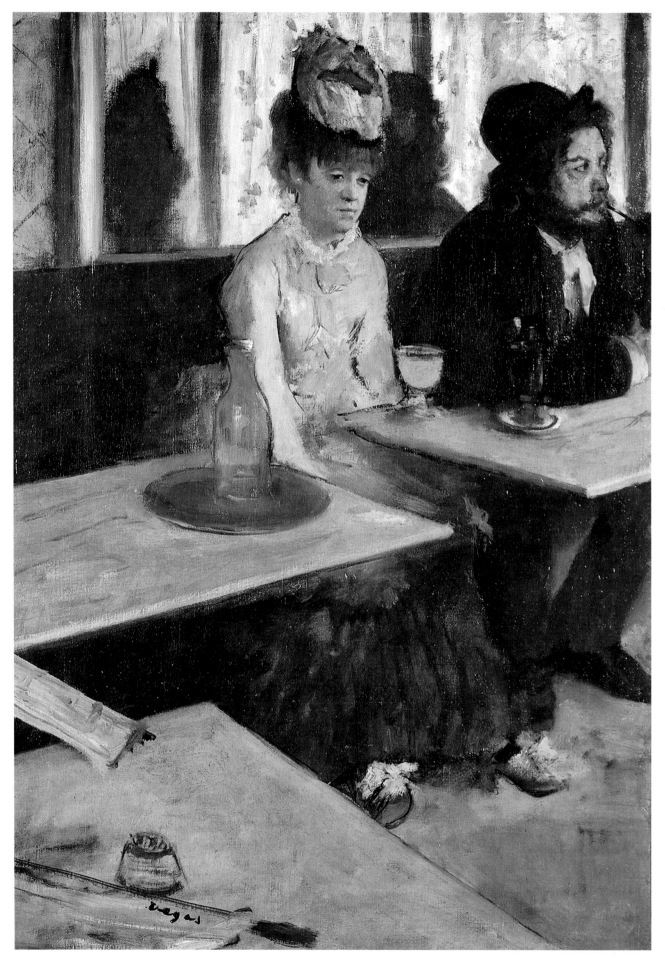

PLATE 19
L'Absinthe (1876)
Oil on canvas, 36¼ x 26¾ inches (92 x 68cm)

For this famous work, Degas used two of his friends as models. The delightful actress Ellen Andrée and the engraver Marcellin Desboutin are seated in the Nouvelle-Athènes café in the Place Pigalle, by this time the meeting place of the independents who had already held their first Impressionist exhibition. The composition, a constructed realist work, creates an atmosphere that must have been very familiar in the cafés around the city, and

quiet drinking, comfortable relationships, self-absorption or drunken oblivion were all part of the ambience. But it is important to realize that the sitters are posed and it would be unfair to assume that either Desboutin or Andrée were addicts. The placing of the figures in the top right and the sharp foreground angles leading to the two heads is a characteristically individualist Degas composition. It might be noticed that the shapes of the table-tops are not supported by legs – a visual inaccuracy but preventing a distraction. The painting was purchased by a Captain Hill of Brighton where it was exhibited in 1876, occasioning a critical comment: 'The very disgusting novelty of the subject arrests attention.'

determine to what, if any extent this perception is accurate. In these days when any perceived association may be helpfully constructive or conversely damaging, it is important to establish the actual connection, not the least in the artistic world, because the strong, positive current appreciation and popular affection for 'Impressionism' will have an effect on Degas' reputation; on the other hand, his work will have an influence in creating the popular understanding of the character of the movement.

There is already in this an inherent problem in determining the extent of Degas' association with the movement since there is no doubt that Degas has been so identified by name that his work has inevitably contributed to the perceived content of Impressionism – to this extent his inclusion is something of a self-fulfilling prophesy. To illustrate the point: his studies of ballet dancers are generally perceived as typical of Impressionist painting – which they assuredly are not. Although it is undoubtedly true that the theatre and ballet held great attraction for Degas, both of these pursuits (as with horse racing) are in the purview of the 'gentleman', of the *haute bourgeoisie* and, as such, could be regarded as of proper interest to an élitist class. Manet was the only other figure in the independent group who could have appreciated these subjects, and it is interesting that he was drawn by Degas, at the races.

As has already been noted, the name 'Impressionism' was coined by a critic, Louis Le Roy, to describe the first

exhibition of 1874, despite the fact that a number of the exhibitors were not Impressionists. Although Degas was one of the principal organizers, and when one considers the work he exhibited, it is evident that it was of a different order and intention from those who are unquestionably recognizable as Impressionists, especially Monet, Pissarro, Sisley and Renoir.

It is also important to note that Degas never accepted the name for the group and continued to propose that the description Independent was more appropriate, indicating that they did not work in a specific, unified style but were united only in opposition to establishment academicism. Degas eventually persuaded the group that this term should be included in the title. He believed that a Salon for Realists should be created and this gives some indication of his own attitude. He saw his work as presenting those aspects of life that interested or inspired him directly: for him, painting was a way of penetrating reality rather than the creation of an impression.

Some association with Impressionist painting is clear and if exhibiting with and associating with the painters who constituted such a group made Degas one of them, then he is an Impressionist by association. Whether he held any belief in the Impressionist philosophy we shall have to examine further: it is certainly true that Monet's belief in painting on-the-spot to catch the immediate sensation, the fleeting 'impression', was certainly not

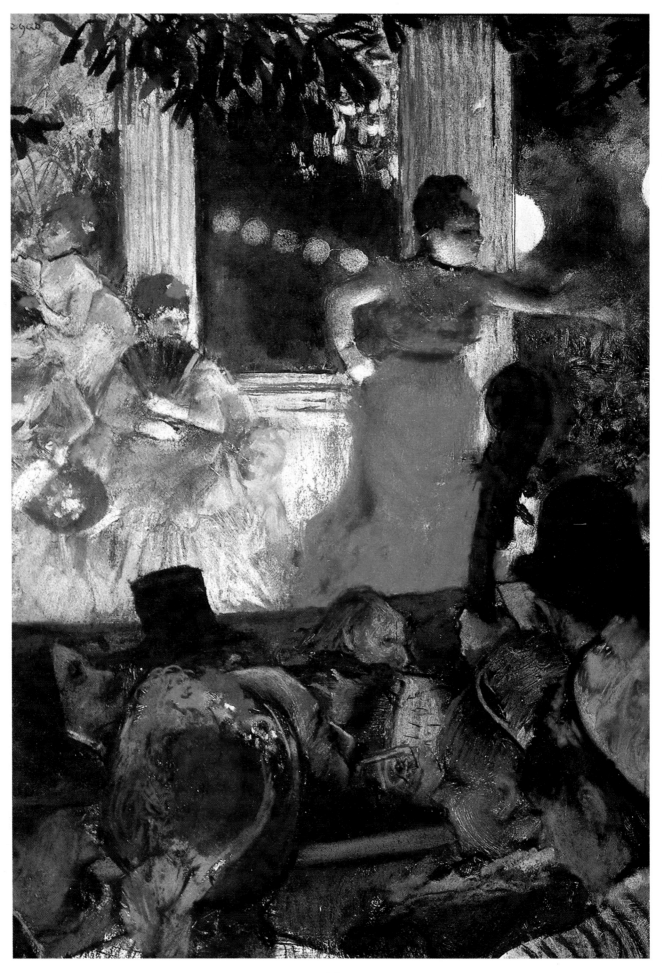

PLATE 20

Café-Concert, Les Ambassadeurs (1876-77)

Pastel over monotype, 14¹/₂ x 10²/₃ inches (37 x 27cm)

One popular form of entertainment of the Parisian social scene, and frequented by Degas, was the café-concert and one of the most highly regarded was at Les Ambassadeurs, a neo-classical building at the bottom end of the Champs-Elysées. Originally used by the working classes and petits-bourgeois, they had become rather more up-market by the time Degas frequented them. Young men-about-town dined and drank, loudly applauded the singers, and made vulgar comments on their physical charms and it is such a scene that Degas depicts here. Two of the last singers that Degas would have seen performing there were Édith Piaf and Josephine Baker. The technique Degas employed on this occasion was to add pastel heightening to monotype.

PLATE 21

Women in Front of a Café: Evening (Femmes devant un café, le soir: un café sur le Boulevard Montmartre) 1877

Pastel on monotype, 16 x 23²/₃ inches (41 x 60cm)

Degas was fascinated by the café society of Paris and made many studies and paintings of the scene from such poignant works as L'Absinthe (plate 19) to the riotous concert in the previous plate. As usual, they are sketched on-the-spot in crayon and later executed in oil paint, monotype, pastel or essence. Degas was concerned to express the different characters of the young girls, possibly prostitutes, who frequented the open cafés. With Degas' usual individuality, the view is from the inside of the café looking towards the street depicted outside. The central figure has a provocative expression, quite sexy, in contrast to the unattractive dark figure on the right.

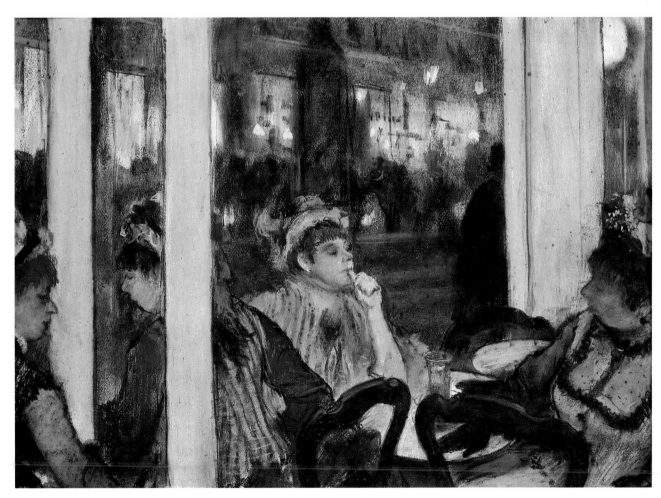

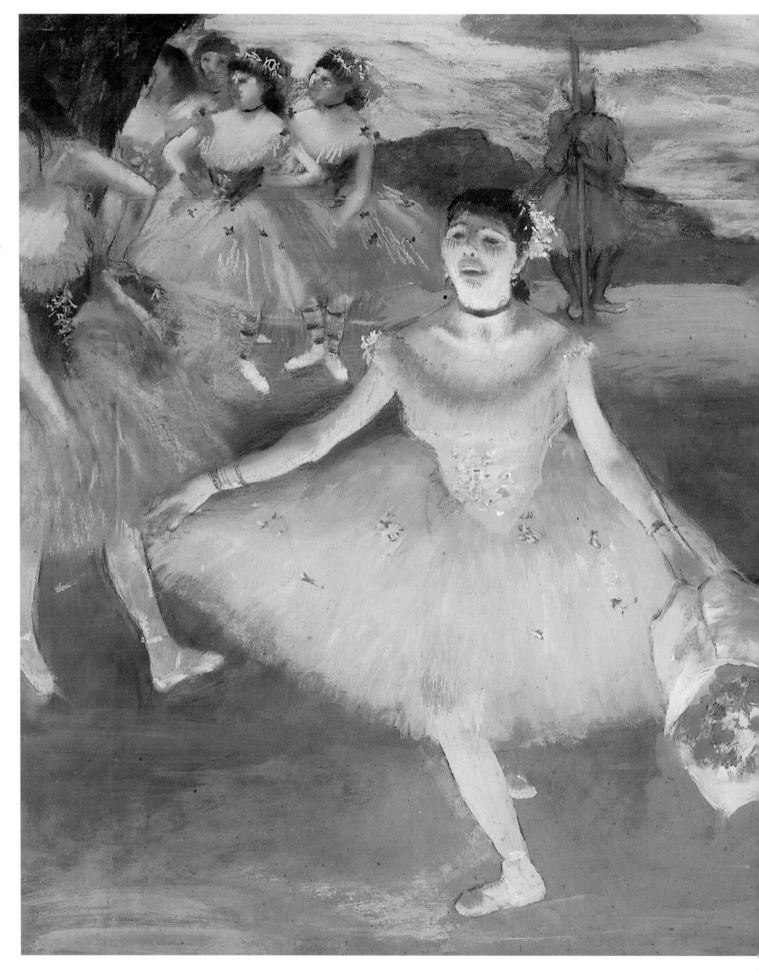

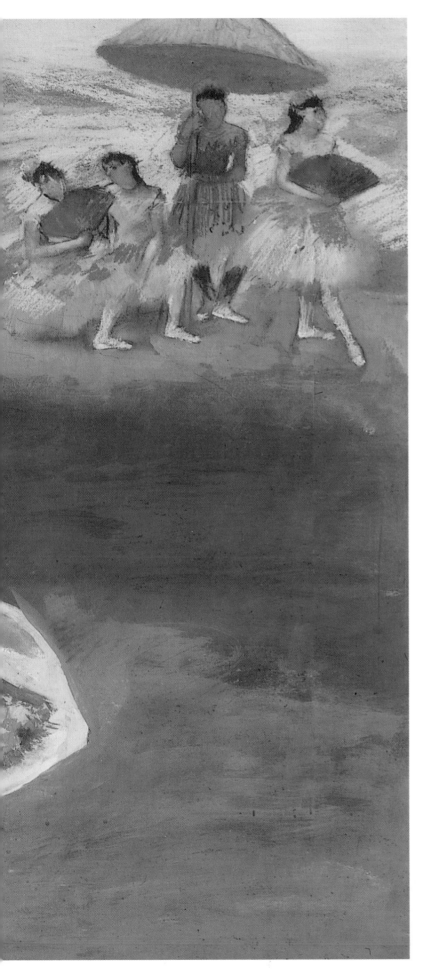

PLATE 22
Dancer Taking a Bow (c. 1877) detail
Pastel on paper mounted on canvas,
28$\frac{1}{3}$ x 30$\frac{1}{2}$ inches (72 x 77.5cm)

*Of all the subjects used by Degas, his dancers are the ones for
which he is best known and are the most widely admired. But it
is not necessarily the subject that most engaged his interest. This
subject was painted about ten times with or without the bouquet,
all at about the same time. When this was painted, the costumes
were all appropriate to the action rather than the typically short
skirts in which Degas has represented them – a typical example of
his disregard for factual realism. As he was often fond of
observing, 'one gives the idea of truth with the false'.*

Degas' view – he was essentially a studio painter.

Ultimately, and truthfully, one has to say that neither
in technique nor intention was Degas ever really an
Impressionist painter. The writer and art critic George
Moore, who knew Degas at the Nouvelle-Athènes,
quoted him as saying: 'No art was less spontaneous than
mine. What I do is the result of reflection and study of the
great masters; of inspiration, spontaneity, temperament I
know nothing.' His search was for an unsentimental
reality, a pictorial objectivity essentially of those subjects
that interested him such as the racecourse and horses, the
theatre and ballet, laundresses at work, and the female
form in studies of women bathing. Although he painted
landscapes they were not, as with the Impressionists
proper, a subject in which he developed his art. In 1892,
in a conversation with some friends he said that he had 21
landscapes for exhibition, at which they all protested that
he had never done any; but he claimed to have done them
all that summer. He said that he had stood at the door of
the coach of the train and could see things vaguely. His
eyesight by this time was very weak.

Although all the Impressionists were subjected to
either vitriolic or dismissive criticism in the early years, by
the time of the last exhibition in 1886, the accessibility
and attractiveness of Impressionist painting, the evident
freshness present in the work, and the recognition of the
sterility and irrelevance of the academic approach had

PLATE 23
Ballet Dancer on Stage (c. 1878)
Pastel over monotype on paper, 22³/₄ x 16¹/₂ inches
(58 x 42cm)

The similarity between this and the previous plate is an example of Degas' use of the same compositional structures in a number of different works. The main difference between these two arises from the squarer shape of the picture area in the former, allowing a more spacious effect, and the large orange parasols and the grouped figures are associated to provide a secondary interest in the background. In this second work, the left side of the picture is similar to the previous one but, because of the higher rectangular shape, the dancer is depicted near the right edge which provides a concentrated and more lyrical composition. The dancer is one of Degas' most elegant portrayals. It is also to be noted that the dancer is seen from above in a much steeper perspective than in the previous work which increases the rythmic flow of the painting by comparison.

resulted in the public and commercial success of all of the major figures. The first stage of the Impressionist revolution had been completed.

For Degas, the period of the Impressionist exhibitions was a time of mixed emotions. He was gratified to be recognized as an important 'modern' painter, and was financially successful; but his eyesight had deteriorated through the 1880s to the extent that by 1892 he was effectively obliged to abandon painting in oils. Pastel remained the only medium open to him; but here his characteristic precision was appreciably diminished to be replaced by bold rich colour and simplified drawing. Despite considerable physical limitations, during this later period he managed to produce some powerful and commanding work – almost from memory.

The last important phase in Degas' work began in 1886 when in the final Impressionist exhibition he offered a series of paintings of women bathing and washing, drying and combing their hair (plates 35–38). In these works, drawn or painted largely from memory but with the aid of photographs, Degas achieves a depth and intensity of treatment of what he has made seem a private, almost secret, activity and that makes these late works some of his most admired. Degas' own comment on these paintings was: 'Hitherto, the nude has always been represented in poses which presuppose an audience, but these women of mine are honest, simple folk, unconcerned by any other interests than those involved in their physical condition.' Here is another: 'She is washing her feet. It is as if you looked through the keyhole.' On another occasion he observed, 'See how different times are for us; two hundred years ago I would have been painting "Susannah bathing", now I just paint "Woman in a Tub".' George Moore commented: '... the naked woman has become impossible in modern art; it required Degas' genius to infuse new life into the worn-out theme. Cynicism was the greatest means of eloquence in the Middle Ages, and with cynicism Degas has rendered the nude again an artistic possibility.' Another general view, voiced by Degas' friend and pupil, Mary Cassatt, in 1893, was that he was 'not an easy man to deal with' – an opinion with which most of his friends would have agreed.

Despite his success, it was not until 1893 that Degas held his first one-man exhibition – at Paul Durand-Ruel's new gallery. In 1886, after the last Impressionist exhibition, Degas had given Durand-Ruel, who was a particular supporter of the Impressionists, exclusive rights to his work. Durand-Ruel was one of an increasing number of dealer-patrons whose collections after the painters' deaths often became the basis of public collections of the moderns. For his first exhibition Degas showed, perhaps somewhat surprisingly since it is not a major element in his *oeuvre*, mainly landscape pastels and monotypes, which included those mentioned above.

Degas was most concerned in these later years with his

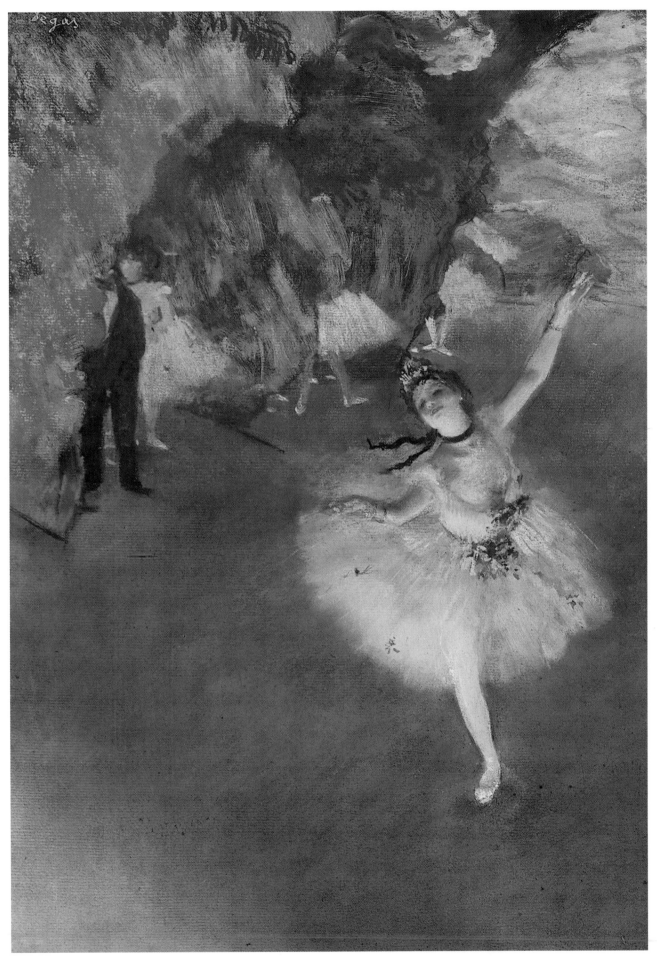

PLATE 24
Woman with Hats (1905-10)
Pastel on tracing paper, 35⁷/₈ x 29¹/₂ inches (91 x 75cm)

During the early 1880s Degas made a number of paintings and pastels of women at their milliners, trying on hats, chatting and serving customers and these gave him another opportunity to create an atmosphere of intimacy and immediacy. The hats also provided him with the sharp colour points among the more restrained colours of the clothes and interiors. On one visit to a fashionable dressmaker with a friend, Mme. Straus, seeing his concentration, asked what interested him. ' The red hands of the little girl who holds the pins,' was his reply. There is also a feeling of respect and regard in these works. It would have been easy to caricature the posturings of fashionable figures but these works show affection and sympathy. This opens a question never resolved. Degas never married and no love affairs have been substantiated. His sexuality and orientation, as it is now described, is not known. He was a close friend of Mary Cassatt and his favourite models speak well of him. On the other hand, there are reports of sexual impotence, of the effects of venereal disease, including a claim that he had 'a lack of the means of making love'. These beautifully drawn and affectionate studies suggest that he was perhaps not entirely the curmudgeonly misogynist that he is usually described as being.

health – and particularly his eyesight. His preoccupation was such that, although he lived until 1917, and towards the end of the First World War (of which he was only dimly conscious), he was to produce little work and even the larger pastels became problematical. One possibility did, however, remain – modelling in clay. Although he could only dimly discern the forms he produced, they responded to his strong tactility and the sculptures that he produced remain as a potent legacy of the 'inner necessity' of the creative artist. The subjects for his sculpture were drawn from his greatest interests: horses, dancers and women bathing.

In 1898 Degas was reunited with his brother René from whom he had been estranged for many years as a result of René's divorce from his blind wife Estelle. Degas regarded René's behavior as indefensible – a feeling perhaps heightened by his sympathetic recognition of the difficulties her blindness would cause her.

From 1900, Degas became increasingly reclusive. Always a private person, he rarely saw any of his friends who were in any event themselves often incapacitated or had died. He was particularly distressed by the death of his boyhood friend and collector of his work, Henri Rouart, who died in 1912. Rouart's collection of paintings, when

PLATE 25
Miss La La at the Cirque Fernando
(1879) see also page 8
Oil on canvas, 46 x 30¹/₂ inches (117 x 77.5cm)

Mademoiselle La La was a negro or mulatto acrobat, known as la femme canon, who is seen here performing at the most famous of the Paris circuses. Degas, like many of his contemporaries, was intrigued by the circus and the Fernando was very near to his home. He made many preliminary studies for this work, one of his larger oil paintings. It was finished in January 1879 and exhibited in May of that year in the Impressionist exhibition. The striking composition shows La La suspended by her teeth, high up in the elaborate vaulted interior and it is said that Degas had trouble with the perspective of the ceiling and hired a professional to make a drawing for him. This is a unique example in Degas' work of a deliberately realist depiction of a highly dramatic effect and may have been made at La La's request, since he knew her personally.

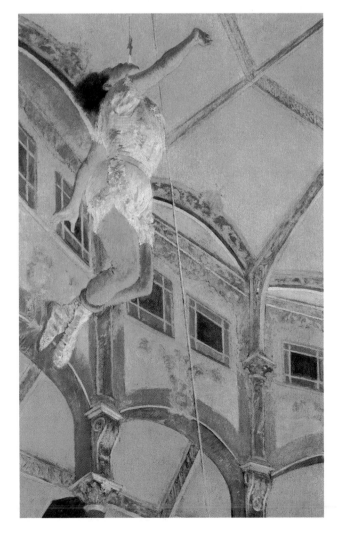

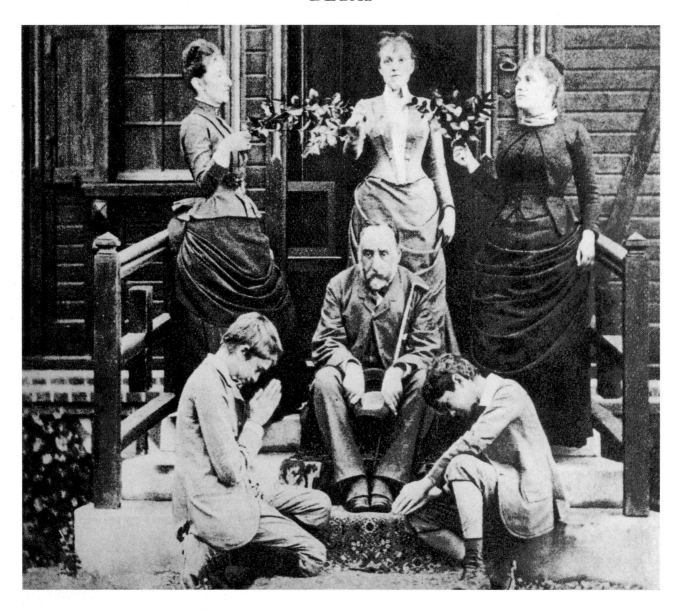

sold, commanded high prices, *Two Dancers at the Bar with Watering Can* by Degas fetching 475,000 francs – at that time the highest price to be realized by a living artist.

Degas' last years were filled with sadness and he always regretted a move that he was forced to make, in 1912, from his home in the rue Victor Massé, where he had lived for 20 years, to an appartment and studio at 6 boulevard Clichy where, on 27 September 1917, he died. He never married and was buried in the family vault in Montmartre Cemetery. As he observed: ' ...there is love; there is work. And we have but a single heart.' His was devoted to art: 'A painter has no private life.'

In 1914, the great collection of Count Camondo was acquired by the Louvre. It included some of Degas' finest works. With the inclusion of these works in the national collection, the victory of the modern Impressionists over the historicist academics was complete. The early modern movements of the 20th century, Fauvism, Cubism,

PLATE 26
Degas Group Skit (1885)

This group, posed by Degas, is intended as a skit on Ingres' painting, The Apotheosis of Homer, *which had been exhibited to great acclaim in the Salon of 1827. Degas wrote in September 1885 about this photograph. 'It would have been better if I had placed my threes muses (the Lemoisne sisters) and my two choirboys (Elie and Daniel Halévy) in front of a white or light-coloured background. The detail of the ladies' dresses is lost. It would have been better if the figures had been moved more closely together.' Little one feels could have rescued this image from bathos and one is surprised that Degas undertook it. He was 41 at the time!*

PLATE 27
Degas in His Studio (c.1895) opposite

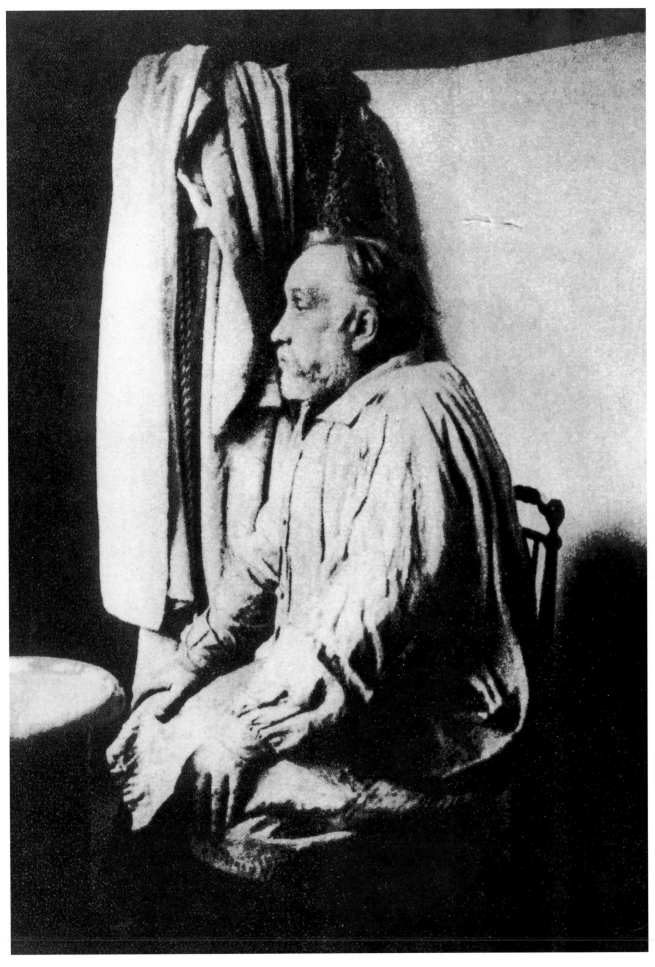

PLATE 28
**Portrait of Ludovic Halévy
and Albert Boulanger-Cave** (1879)
Pastel and distemper on paper, 31 x 21²/₃ inches
(79 x 55cm)

These two gentlemen, friends of Degas, are depicted at the Opéra where men of repute were permitted to go backstage, thus causing it to develop into a social meeting place. Ludovic Halévy was a special friend of Degas'. Born in the same year, they were close companions until the Dreyfus affair which severed many friendships and became a cause célèbre prompting Zola's famous pamphlet 'J'Accuse'. Halévy became a librettist (Carmen, La Belle Hélène, La Vie Parisienne) and novelist and is seen in a number of Degas' works. He also illustrated Halévy's story of backstage life with a series of monotypes. Daniel Halévy, Ludovic's son and a great admirer of the painter, is the source of much information on him in the notebooks he kept of Degas' frequent visits during the period of close intimacy Degas maintained with the family. Degas exhibited the painting in the 1879 Impressionist show.

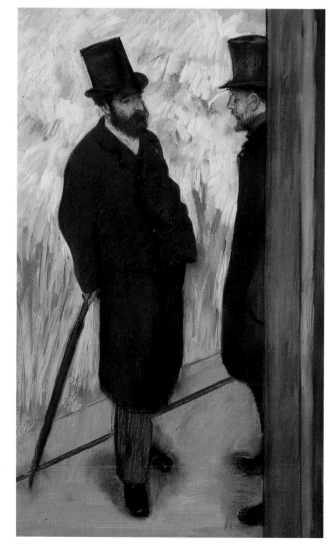

Futurism, and others, were the already recognized avant garde – the new art. After Degas' death, Renoir had a further two years to live, while Monet had nearly ten years of life and active work left to him although nearly all of his other contemporaries died before him.

DEGAS THE ARTIST

In outlining the course of Degas' less than dramatic life, some indication of the qualities and nature of his artistic achievement has been given; but it is necessary to consider his work more fully to understand the special contribution he made, both to his own time and as an inspiration to subsequent painters.

His work changed and matured gradually. The first serious work, recognizably his, is part of the academic historicist tradition while he was still being influenced by his position in society as part of the 'establishment' and hoping for recognition as a successful amateur in a professional world. At that time, artists were accorded intellectual authority, often lionized, and revered by students and members of the intelligentsia. It must be remembered that in the 19th century no art schools existed as we now know them, and most aspiring painters went through a form of apprenticeship with a recognized 'master'. (This was traditional in the Renaissance period when the young Leonardo was apprenticed in the studio of Andrea Verrocchio.) Renoir, Monet, Bazille, Whistler and

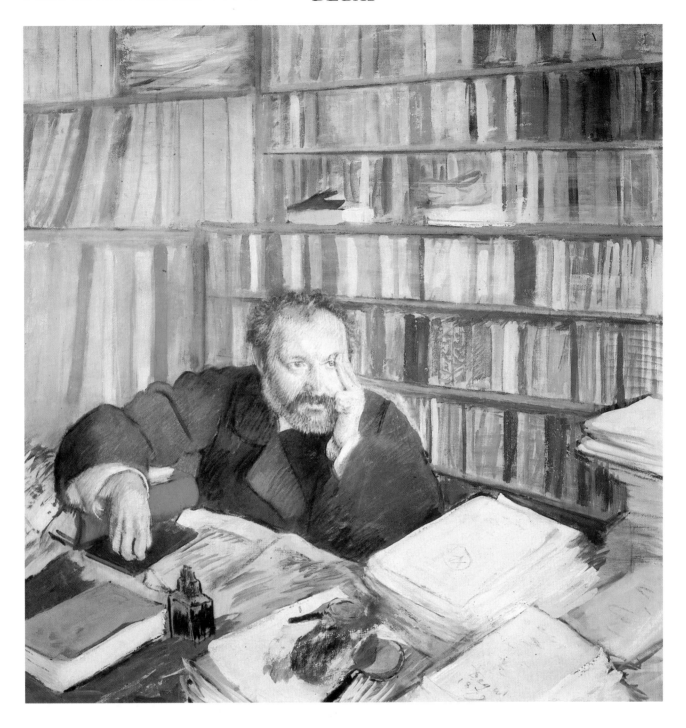

PLATE 29
Edmond Duranty (1879)
Gouache and pastel on canvas, 39³/₈ x 39³/₈ inches
 (100 x 100cm)

Duranty was a writer and critic and Degas' friend. Degas first met him at the Café Guerbois among Manet's group. He became a strong supporter of Degas and they influenced one another in their work, Duranty naming Degas in one of his novels. His reviews of Degas' works in the Impressionist exhibitions were favourable, as were those of most critics, including Geffroy, Huysmans and Mallarmé. After Duranty died, Degas solicited works from his friends for a sale to raise funds for his widow. This painting is an example of Degas' personal combination of different methods and materials to achieve the end he sought. The books are mainly in gouache (opaque watercolour), while Duranty's head and hands are constructed in pastel. The placing of the figure, and the emphasis on the books which surround him, identify Duranty's profession in a work of great distinction. It has been suggested that it may have influenced Cézanne to also use books in his portrait of Geffroy.

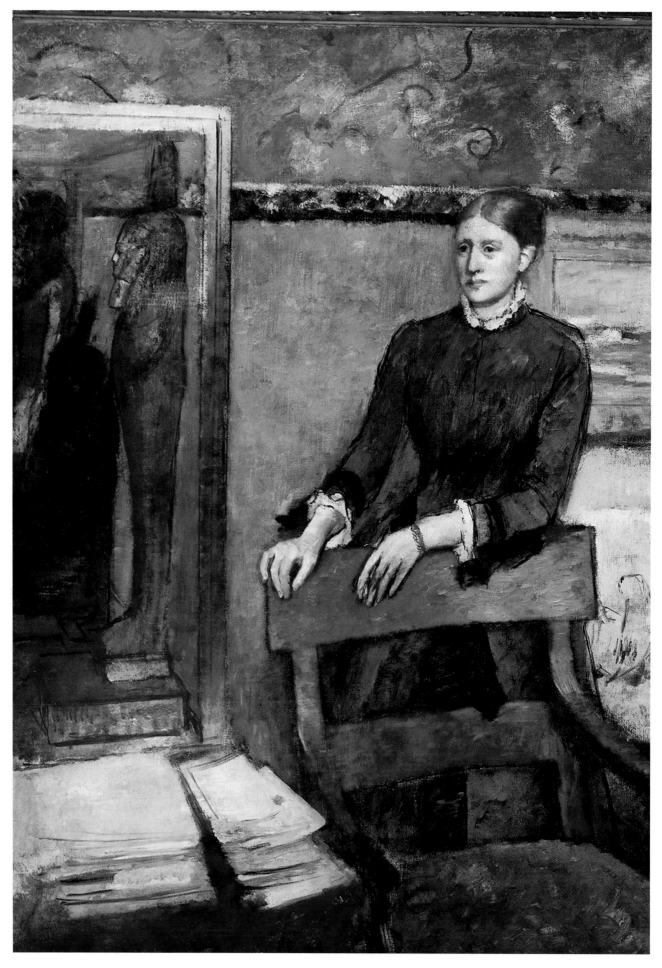

PLATE 30
Hélène Rouart in Her Father's Study (1886)
opposite
Oil on canvas, 64 x 48 inches (162 x 123cm)

Hélène, Henri Rouart's daughter, was born in 1863, the year of the Salon des Refusés, and was a member of a family which Degas held in great affection. This portrait shows her in her 20s as a serious, wistful young lady in a cultured environment, revealing her father's interest in ancient Egyptian art. Degas had first painted Hélène when she was a small child and her red hair attracted him, causing him to write to her father in Venice when she was 20 to say that he would have liked to have joined them in the city 'where her hair and colouring are of the kind so much admired in the past' – recollections of Titian, evidently. As with a number of Degas' works, this painting is uncompleted and he made a number of studies of the composition in a variety of poses and had also at one time intended to include Hélène's mother. Richard Kendall in his catalogue 'Degas: Beyond Impressionism', suggests that work on the painting occurred as late as 1895.

PLATE 31
Diego Martelli (1879) detail above
Oil on canvas, 43¹⁄₃ x 39³⁄₈ inches (110 x 100cm)

Diego Martelli was a Neapolitan engraver who worked in Paris and Degas used to drop in for a friendly chat in Italian at his studio where this portrait is located. Degas made fewer portraits as he got older and this is a gesture of friendship. Its informal treatment in the cluttered interior suggests the captured moment rather than the posed figure but, as we observe with his women bathers, it is carefully composed in its informality. The angle of vision is from above, indicating the close proximity of sitter and painter and few painters would balance the figure turned away from a cluttered still-life of table with bric-à-brac. It is typical of Degas, however, as is the bright sharp note of the slippers and the folding chair. The delightful intimacy of the painting makes it one of Degas' uniquely attractive works.

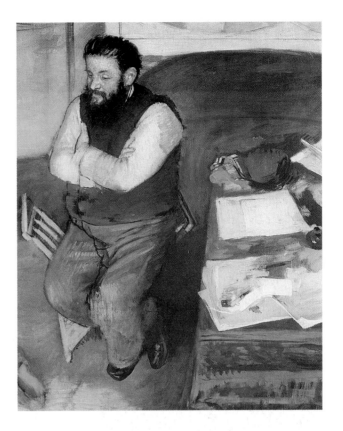

Sisley, for instance, were pupils in Gleyre's Academy. Charles Gleyre was a Swiss painter who took over the studio of Paul Delaroche in Paris where his historical paintings gained him a high reputation at the Salon. Like most painter-teachers, he enjoyed a steady income from his articled charges. He is unusual in that he recognized the qualities of these students and it is perhaps an appropriate footnote to his career that he died in the year of the first Impressionist exhibition in which some of these same pupils exhibited.

Degas' first teacher, as previously mentioned, was Louis Lamothe. He had spent a short period in the studio of a little-known painter, Félix-Joséph Barrias, but Degas' father, Auguste De Gas, is believed to have consulted Valpinçon for advice regarding his son's artistic education who, in turn, is thought to have consulted Ingres who recommended that he should train under one of his own pupils, Louis Lamothe. (De Gas was the family name before the two syllables became joined: the correct pronunciation is therefore with the 'e' unaccented and is not, as is often encountered, pronounced Dégas – Daygas.) Lamothe was a meticulous follower of Ingres although himself a minor figure. The advice was taken and the influence significant. Ingres' well known passion for drawing, and apparent to Degas on their first meeting, was certainly transmitted to him through Lamothe. It became the cornerstone of Degas' art.

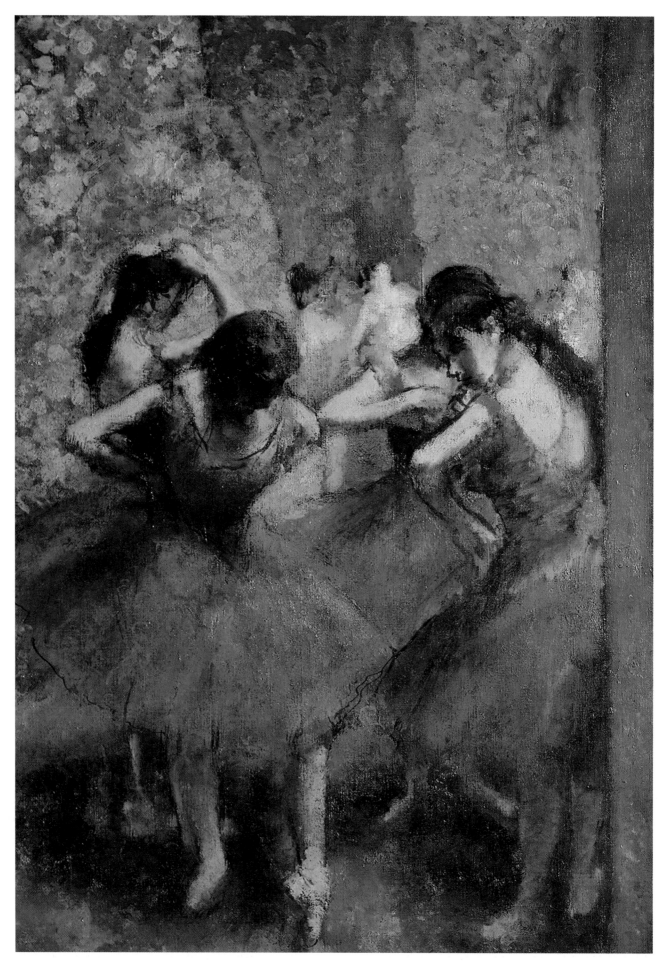

PLATE 32
Blue Dancers (c.1890) detail opposite
Oil on canvas, 33⁷/₁₆ x 29³/₄ inches (85 x 75.5cm)

*Most of Degas' studies of the ballet were made backstage at the
Opéra where he would coax the girls, 'the little rats', to stop a
while in order that he could draw them in various poses. These
sketches were either worked up further in his studio or formed the
basis for a composition containing a number of figures. The
sketches were usually in pastel and the groups in pastel, essence or
oil although on occasions, particularly in his later work, he used a
combinations of all these media.*

PLATE 33
Singer in Green (1884) detail below
Pastel on paper, 23 x 18 inches (58.4 x 45.7cms)

*A brilliant pastel of a popular entertainer – gaudy, young and
precociously confident in a costume of audacious vulgarity and set
in a theatrically bright and indeterminate setting. It encapsulates
the very nature of popular entertainment in a simple image.
Although unknown, the young girl is the quintessential theatrical
personality, sensual and engaging in the remote footlights but
essentially unreal and probably unattractive in the harsh light of
day. The extraordinary quality of Degas' direct draughtsmanship
in the immediacy of the pastel technique confirms his mastery of
the difficult method.*

The essential qualities of drawing are difficult to
identify without qualification. For our purposes it might be
described as delineating on a surface the intentions of the
draughtsman, in materials and in a form that expresses
effectively and accurately his intention. In a charming and
now well known explanation, a small child described
drawing thus: 'I think and then I draw a line around my
think.' Perhaps this is a better way of expressing the nature
of drawing than any more elaborate definition, including
the one above. Ingres was regarded as the great academic
draughtsman of the age and Lamothe's stressing of the
importance of drawing struck a positive chord in Degas,
although he had little regard for Lamothe himself. Drawing
became the backbone of Degas' art from this early stage.
The ability does not, however, come God-given and fully
formed. It must be worked upon, and for Degas this meant
a constant devotion to drawing a great variety of subjects in
many different media. From early academic studies and
through the course of his life, as with all great
draughtsmen, he developed a freer, more adaptable and
adventurous method and his later drawings, less precise and
bolder, though sensitive and penetrating, represent some of
the finest examples of draughtsmanship that we have.

It must always be remembered, however, that drawing
is not solely or even mainly a linear activity. The definition
offered in the previous paragraph does not specify thin
pencil or pen-drawn line and drawing with a brush, chalk,

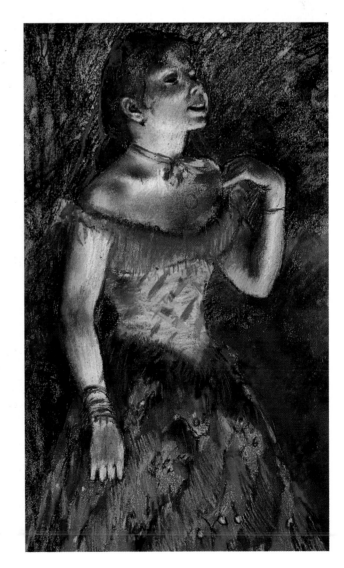

PLATE 34

Women Ironing (c. 1884-86) detail
Oil on canvas, 30 x 32 inches (76 x 81.5cm)

A subject that attracted Degas but resulted in relatively few paintings, this was possibly inspired by the Goncourt brothers whose writing Degas admired. Apart from their famous Journal, a chatty and imaginative gossip about Parisian life, they wrote novels and in the introduction to one of them observed: 'We have asked ourselves if what one calls the "lower classes" have not a right to a novel.' Degas' interest may have been thus stimulated by the sight of the many laundresses who were constantly to be seen on the streets with their parcels of laundry for the gentry. For the earliest depiction in 1869 of a girl ironing, Degas used a model and later produced from sketches a number of studies of laundresses, including the late one illustrated. Here the squalid, barren scene reveals the two figures in a carefully balanced composition with Degas' special use of colour very evident; the orange, red and pink notes enliven the scene composed of blues, greens and greys. The careful delineation of the tired or drunken figure on the left is balancing the less distinct figure concentrating on her work, on the right. Is there a psychological message in the different treatments, or is it reality?

pastel and even a spatula or fingers is not excluded. Drawing is a part of painting and, indeed, sculpture. It is the expression of the defined sensitivity of the artist in any medium.

One of Degas' favourite methods was pastel-painting. There are certain specific qualities in pastel that are attractive to the artist. The ideal for any painter is that his intention should be immediately achieved and evident and that it should not change with time. There are many reasons why changes should occur in painting, both physical and chemical, and the method least subject to such changes is pastel which is applied to the surface as almost pure colour with few additives to affect it. This leaves the surface in a delicate condition but the colour is the purest expression of the artist's intention that can be achieved. It was this immediacy of effect that attracted Degas, especially in subjects where movement was inherent such as in horses or dancers. It might be noted that it is possible to use a fixative for pastel that has a minimal effect on it, helping it to retain its brilliance longer than either watercolour or oil. This may partly account for the popularity of Degas' pastels whose brilliance is apparent to all observers. Although there are a number of earlier, particularly 18th-century, pastellists of considerable ability, they operated mainly as portraitists (less expensive and more direct than oil portraits) and Degas explored the use of pastel in a range of

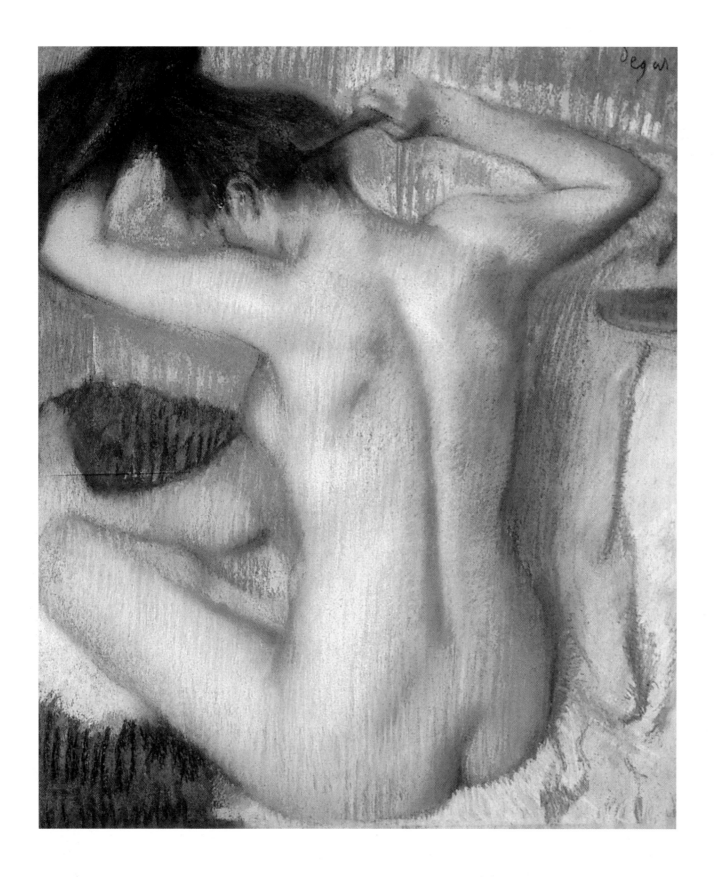

PLATE 35

Woman Brushing Her Hair (c. 1885) detail

Pastel on card, 20⁷/₈ x 20¹/₂ inches (53 x 52cm)

In his late works depicting women engaged in bathing and associated activities, which continued from the 1870s to the end of his active career, Degas frequently chose the subject of women combing their hair or having it combed by a maid. The paintings appear to be casual, unobserved studies of the nude but are constructed from studies of models or directly from models in the studio. What Degas himself described as a 'keyhole' effect is in fact a studied artificial realism which produces a convincing voyeuristic result and there has been much discussion on the importance of these works and their revolutionary character. Degas, as noted on page 50, made the point that had his nudes been painted earlier they would have been given a literary, biblical or historical title, such as 'Susannah bathing', but that now he would call them merely The Tub (plate 36). This pastel is an exquisitely drawn study of a woman's back in the subtlest colour and is the result of many sketches.

effects and with such marked sensitivity that he may be regarded as one of greatest practitioners of the method. His contemporary, Odilon Redon, was also a fine pastellist but his work was part of the Symbolist mysticism and his colour has an expressionist intensity in sharp contrast to Degas' sensitive realism; together they reveal the range possible in this responsive medium.

Degas also employed two further techniques, usually or often in conjunction with pastel. These are not commonly used but Degas found them useful, particularly as his sight deteriorated and made precision difficult for him. They are the use of monotype and painting with essence rather than oil. Monotype is a method of transferring an image painted on glass onto paper, pressed onto the glass and pulled free so that most of the paint, in no way absorbed into the glass, leaves a less than complete image on the paper which may then by drawn on with pastel. More than one print can be produced from a single subject in this way, making alternative colour sketches possible. Essence painting consists in using an essential oil such as oil of cloves, or lavender or spikenard. This gives something of the effect of thin watercolour but with more opacity in the colour, providing a more 'solid' effect. Degas applied pastel to both monotype and essence sketches.

Degas was nevertheless a trained practitioner in oil painting and here, too, he developed a mastery of the method adopted by the majority of professional painters.

The versatility of oils as a method has been noted by most observers. From the finest and most detailed, to the broadest and most free applications of paint, the oil method responds exceptionally well. The type and form of the brushes or other applicators determines the quality and character of the work more than the method itself. In this century we have become accustomed to paint being applied with great freedom and some disregard for permanence, but in the 19th century and earlier, the attitude to the creation of a work of art was that it should be important enough to be revered and preserved. Experiment was dangerous, the most famous example of this being Leonardo's attempt to use oil on a plaster wall for the *Last Supper* in Milan – its ruinous state a witness to the failure. This necessitated a concern for the method itself, the use of the finest materials and the longest lasting pigments, as well as knowledge of their chemical interaction. There were well known exceptions to this. For instance, J. M.W. Turner, in his pursuit of effect, was capable of achieving results which would inevitably ensure the quick deterioration of the work. But most painters, Degas included, were careful technicians.

The preparation of the canvas or board was significant to the final effect, and canvases were usually prepared with a white ground. Historically, canvases and colours were prepared in the studios by the assistants, but during the 19th century manufacturers and colour shops appeared and

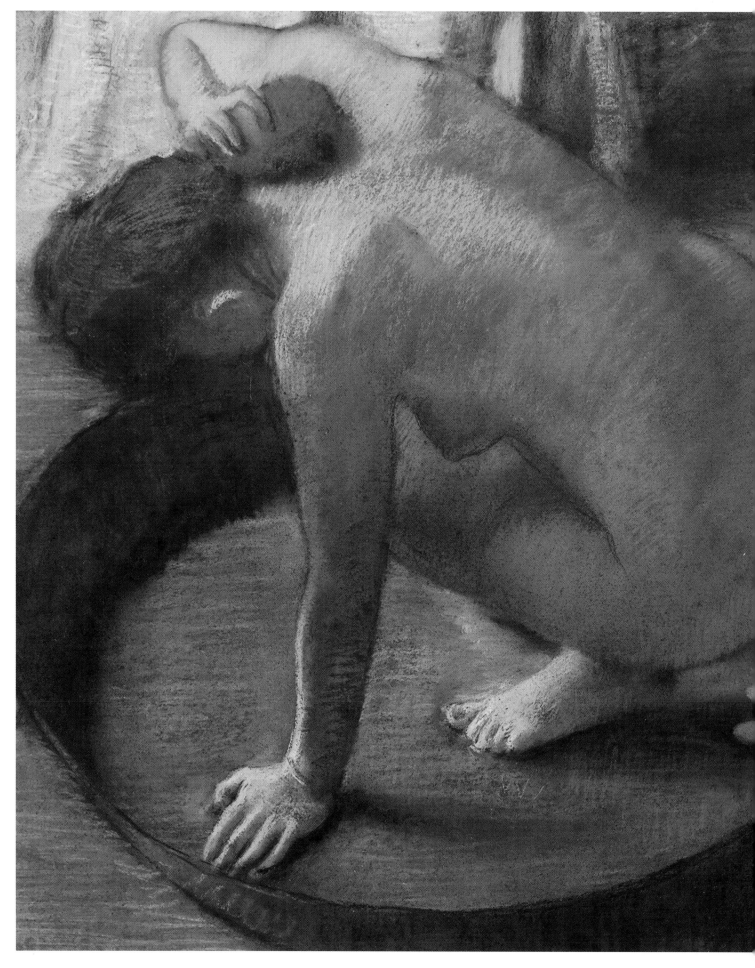

PLATE 36
The Tub (1886) detail
Pastel on card, 23²/₃ x 32²/₃ inches (60 x 83cm)

*This famous work shows many aspects of Degas' methods.
Firstly, it will be noted that the sense of intimacy that he has
achieved is the result of the steep perspective of the table-top
which, when analysed, is clearly seen to be inaccurate in relation
to the objects on it, which are viewed (to make their supporting
role as a curved shape behind the figure visually convincing) from
a lower eye-level. At the same time the figure is seen from
immediately above and the viewer looks almost directly down into
the circular tub. More might be said on this compositional matter
but it is another occasion on which Degas uses visual devices to
convey a sense of the truth. The draughtsmanship is as acute as
always and it is apparent that despite the deterioration of his
eyesight, he is still able to produce a closely modelled image and
subtle colour relationships in this sympathetic and tender work.
Huysman's comments on this pastel are somewhat different. He
describes the figure as 'a red-haired corpulent swollen female' but
goes on to say that 'never have works been so lacking in slyness
or questionable overtones'. The pastel was shown with others in
the series in the eighth and last Impressionist exhibition of 1886.*

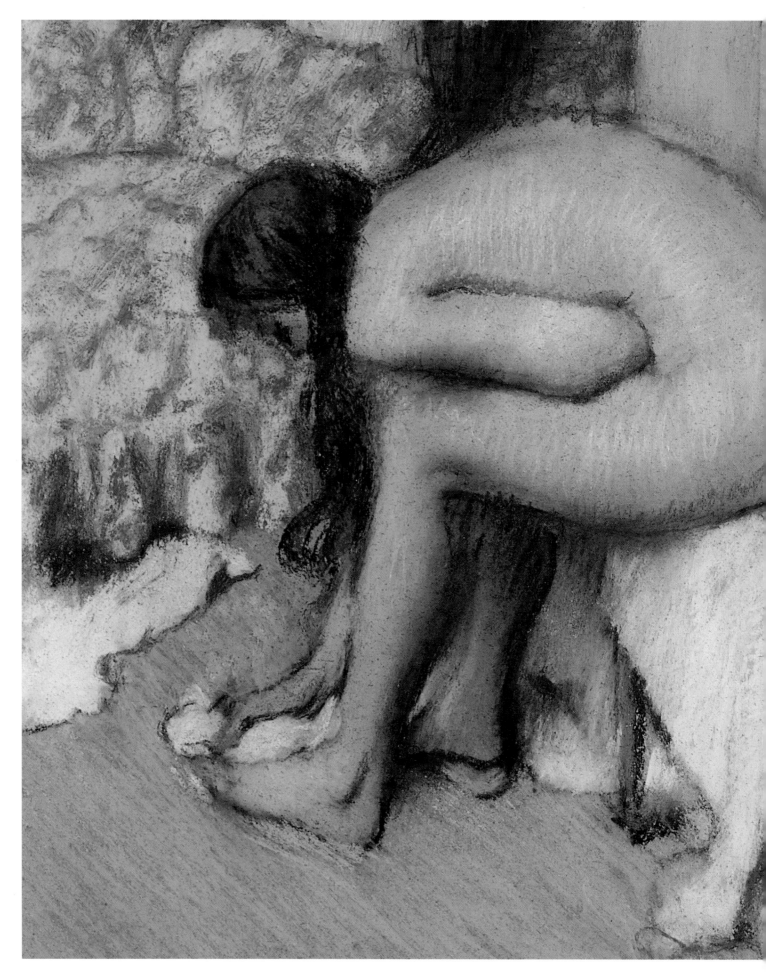

PLATE 37

After the Bath, Woman Drying Her Feet
(1886)

Pastel on paper, 21³/₈ x 20⁵/₈ inches (54.3 x 52.4cm)

With all the studies of women engaged in their toilette there are usually a number of versions, some almost identical, some with variations. This is one of the more completely resolved works of great authority. It is interesting to note the vertical dark area on the right suggestive, perhaps, of an open door and implying the sense of security of the bather but a voyeurist artist peering in. It was exhibited in the Impressionist show of 1886.

PLATE 38

After the Bath (c.1885) pages 70–71

Pastel, 18⁷/₈ x 34¹/₄ inches (48 x 87cm)

This seems to have been an attractive pose for Degas' studies since it appears, although in reverse, in his early academic painting Scene of War in the Middle Ages (plate 5), almost exactly similarly placed.

the painters in Degas' day usually patronized them. In general, painters were supplied with what they needed but, as is the unfortunate way of commerce, adulteration in order to save money and thereby make more profit began to increasingly occur and the artists most concerned with their own work often continued to grind and mix their own pigments. During the 1840s, pigment colours in tubes became available and this had a liberating effect on painters in two major respects: firstly, it obviated the lengthy preparation of the traditional method and secondly, it enabled artists to paint out-of-doors where and when they wished without having to carry heavy materials about with them. This last was a great advantage to Impressionists like Monet but of no great interest to Degas who, as we have noted, deplored *plein-air* painting. In this century, the tubed paints, often manufactured from coal-tar dyes, have come to dominate the market.

The problems caused by Degas' deteriorating vision during and after the 1870s meant that consideration of technique became secondary to him, his main concern being to produce an image that was visually acceptable. With pastels, this meant a larger than usual picture area and more brilliant colour as his perception of colour weakened. The result with pastels, as also with oils, was to increase the intensity of colour and tonal variation and to lessen the precision, so important to him, of his drawing.

Continued on page 74

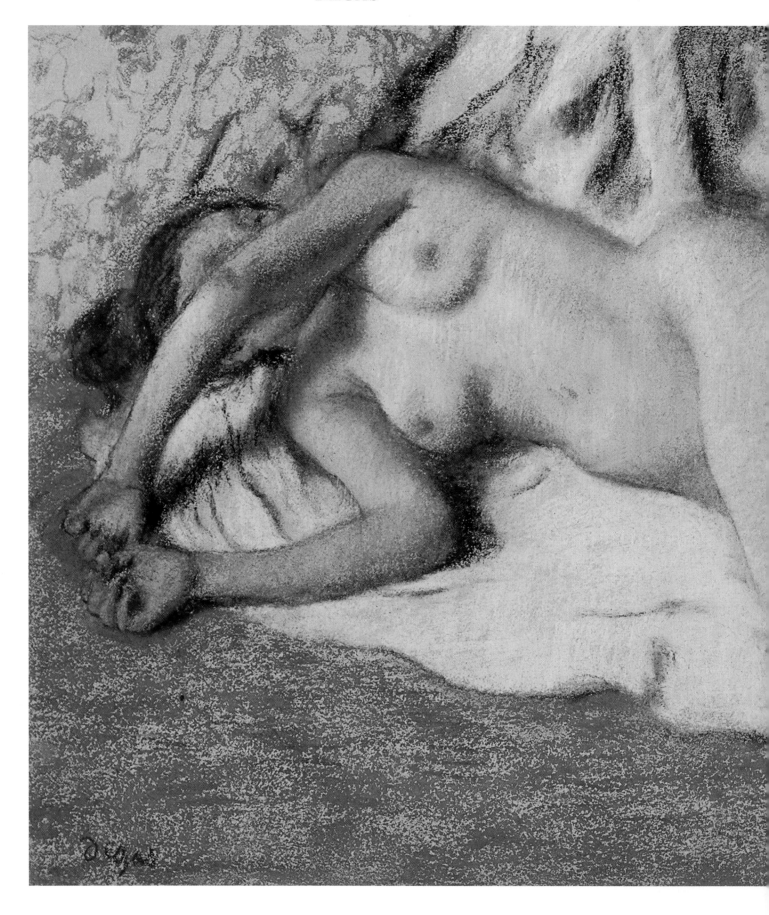

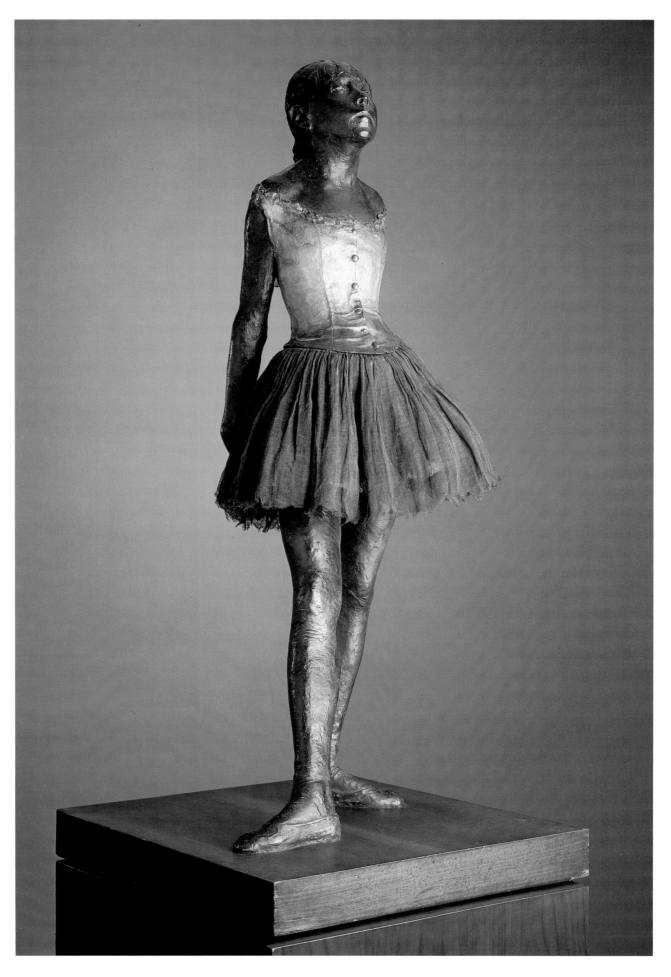

PLATE 39
The Little Dancer Aged Fourteen (1878–81)
opposite
Bronze with muslin skirt and satin hair ribbon, on
wooden base. Height excluding base 39 inches (99cm)

PLATE 40
Dancer Fastening the Strings of Her Tights
(1895-90) top right
Bronze. Height 16½ inches (42cm)

PLATE 41
Arabesque over the Right Leg, Left Arm in Front (1892-95) below right
Bronze. Height 8 inches (20cm)

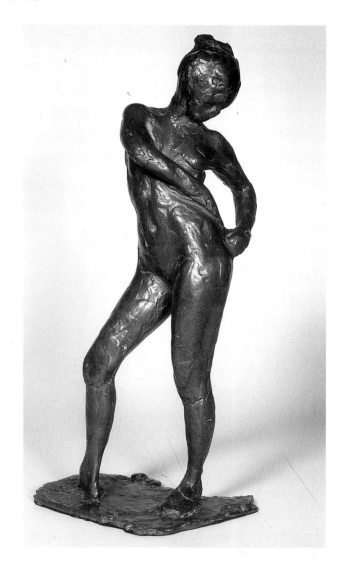

*The subject of Degas' sculpture has been, for the most of the
period since his death, given a minor place in the consideration of
his* oeuvre *and it is only recently that a reassessment of its
content and importance has been made. Curated by Richard
Kendall, exhibitions at the National Gallery, London and the
Art Institute of Chicago have drawn attention to its significance,
through his introductory essays. Most of the sculptures have been
translated into bronze in very limited editions which have
allowed both a greater familiarity and serious misapprehension.
According to Vollard, Degas '...could not take the responsibility
of leaving anything behind him in bronze; that metal, he felt
was for eternity.' His sculptures were all created in either 'red
wax' or in clay and cast in plaster. And although the* Little
Dancer Aged Fourteen *is a well known work and now in
bronze, it is only one of a number created in wax and added
materials, such as ribbons and tulle. They were also well known
by his contemporaries although Degas did not exhibit them.
George Moore, a keen observer of the art of the period, saw them
and commented: '...dancing girls modelled in red wax, some
dressed in muslin skirts, strange dolls – dolls if you wish, but
dolls modelled by a man of genius'. Others, including Renoir,
who saw these works in Degas' studio thought they were of great
significance. Richard Kendall says that Louisine Havemeyer,
Mary Cassatt's great friend, tried unsuccessfully in 1903 to buy
the* Little Dancer *and considered it 'one of the greatest works of
art since the dynasties of the Nile'. It was intended to be shown
in the 1880 Impressionist show, but was not finished and was
included in the show the following year. The bronze version in
an unknown number was made starting in 1922.*

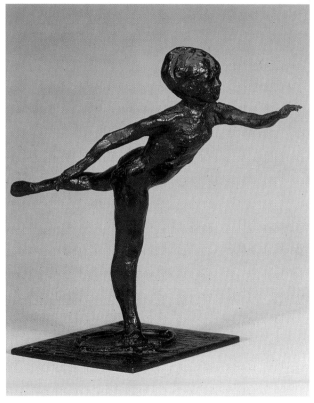

PLATE 42
Horse With Lowered Head (c.1895–90)
Bronze. Height 7 inches (18cm)

Degas' interest in horses started early and his painting and pastels of racecourse subjects signalled his abandonment of academic restraints. The vitality and knowledge to be found in his sculptured horses indicates this continued passion into later life.

Continued from page 69

As has already been mentioned, one activity was a great help as Degas' sight-loss increasingly prevented him from seeing the images that he was creating. His acute sense of touch enabled him to model forms in clay. These were usually small figures of dancers, of women bathing or drying themselves after bathing, of horses in various stages of motion. These tactile creations were an *aide mémoire* to the pastels, monotypes and essence paintings, often with pastel additions. These sculptures together form another important element of the total Degas *oeuvre*.

The few specific examples here will illuminate the development of the variety and quality of his use of the different techniques outlined above and illustrated in this book.

The summation of Degas' achievement was to add a distinctive technique and traditional qualities to the output of the revolutionary movement which is known as Impressionism. The extension of the Impressionist contribution is present in the painters known as Post-Impressionists, although they were the contemporaries of Degas. The four most important of these were Cézanne, Seurat, Gauguin and Van Gogh – all of whom died over a decade before Degas himself died.

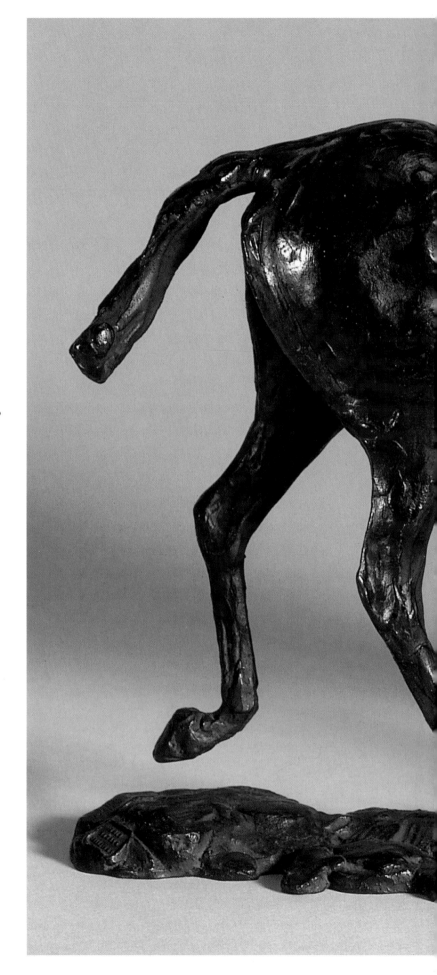

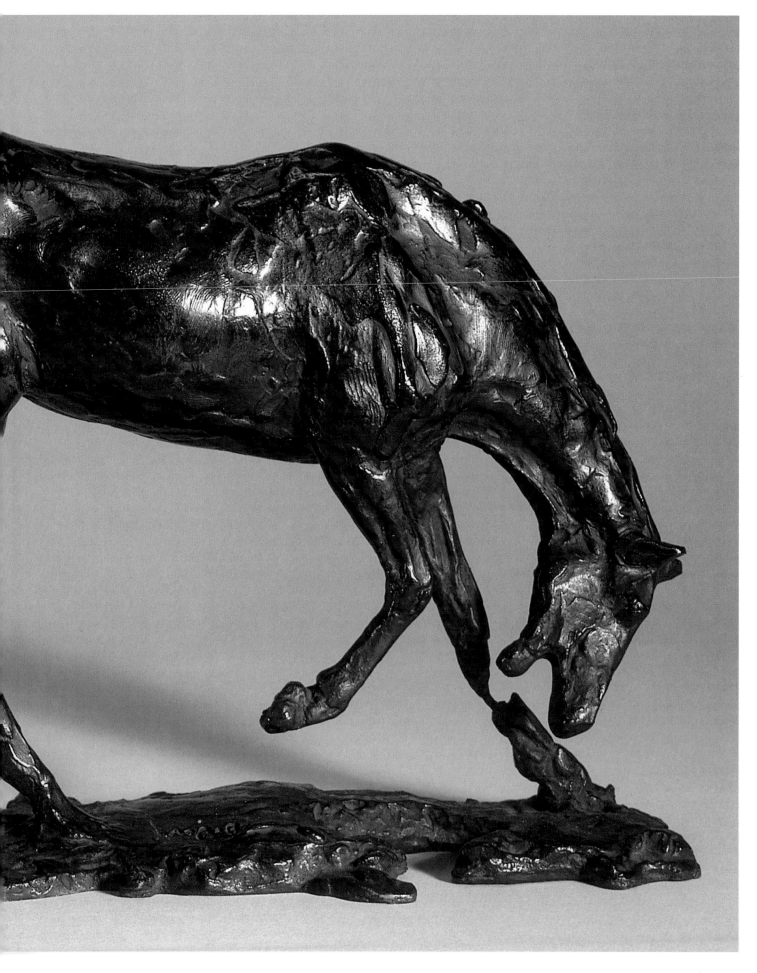

ACKNOWLEDGEMENT

The Publishers wish to thank the following for providing photographs, and for permission to reproduce copyright material. While every effort has been made to trace and acknowledge copyright-holders, we wish to apologize should any omissions have been made.

Self-Portrait with Crayon

Musée d'Orsay/Giraudon, Paris

René-Hilaire De Gas

Musée d'Orsay/Giraudon, Paris

The Bellelli Family

Musée d'Orsay/Giraudon, Paris

Semiramis Founding Babylon

Musée d'Orsay/Giraudon, Paris

Scene of War in the Middle Ages

Musée d'Orsay/Giraudon, Paris

Self-Portrait with Hat

Calouste Gulbenkian Museum, Lisbon/Giraudon, Paris

Gentleman's Race: Before the Start

Musée d'Orsay/Giraudon, Paris

At the Racecourse, With Jockeys in Front of the Stands

Musée d'Orsay/Giraudon, Paris

Amateur Jockeys on the Course, beside an Open Carriage

Musée d'Orsay/Lauros/Giraudon, Paris

Léon Bonnat

Musée Bonnat, Bayonne/Giraudon, Paris

Thérèse De Gas

Musée d'Orsay/Lauros/Giraudon, Paris

Interior Scene, known as The Rape

Philadelphia Museum of Art,
Collection Henry Macilhenny/Bridgeman/Giraudon, Paris

The Orchestra of the Opéra, Rue Le Peletier

Musée d'Orsay/Giraudon, Paris

Jeantaud, Linet and Lainé

Musée d'Orsay/Giraudon, Paris

The Cotton Exchange at New Orleans

Musée des Beaux-Arts, Pau/Giraudon, Paris

The Pedicure

Musée d'Orsay/Lauros/Giraudon, Paris

The Dancing Class

Musée d'Orsay/Lauros/Giraudon, Paris

Dancers Resting

Christie's, London/Bridgeman/Giraudon, Paris

L'Absinthe

Musée d'Orsay/Bridgeman/Giraudon, Paris

Café-Concert, Les Ambassadeurs

Musée des Beaux-Arts, Lyon/Giraudon, Paris

Women in Front of a Café: Evening (Femmes devant un café, le soir: un café sur le Boulevard Montmartre)

Louvre/Giraudon, Paris

Dancer Taking a Bow

Musée d'Orsay/Giraudon, Paris

Ballet Dancer on Stage

Musée d'Orsay/Lauros/Giraudon, Paris

Woman with Hats

Musée d'Orsay/Giraudon, Paris

Miss La La at the Cirque Fernando

The National Gallery, London/Bridgeman/Giraudon, Paris

Degas Group Skit

Hulton Getty

Degas in His Studio

Hulton Getty

Portrait of Ludovic Halévy and Albert Boulanger-Cave

Glasgow Art Gallery, Scotland/Bridgeman/Giraudon, Paris

Edmond Duranty

Glasgow Art Gallery, Scotland/Bridgeman/Giraudon, Paris

Hélène Rouart in Her Father's Study

The National Gallery, London/Giraudon, Paris

Diego Martelli

National Gallery of Scotland, Edinburgh

Blue Dancers

Musée d'Orsay/Giraudon, Paris

Singer in Green

Trewin Copplestone

Women Ironing

Musée d'Orsay/Giraudon, Paris

Woman Brushing Her Hair

Hermitage Museum, St. Petersburg/Giraudon, Paris

The Tub

Musée d'Orsay/Lauros/Giraudon, Paris

After the Bath, Woman Drying Her Feet

Toronto Art Gallery, Canada/Giraudon, Paris

After the Bath

Musée du Louvre, Cabinet des Dessins, Paris

The Little Dancer Aged Fourteen

Christie's, London, Private Collection/Bridgeman Art Library, London

Dancer Fastening the Strings of Her Tights

San Diego Museum of Art/Bridgeman Art Library

Arabesque Over the Right Leg, Left Arm in Front

Fitzwilliam Museum, University of Cambridge/Bridgeman Art Library,

Horse With Lowered Head

Fitzwilliam Museum, University of Cambridge/Bridgeman Art Library